_____ *Growing Up in* _____
CONCORD,
NEW HAMPSHIRE

Growing Up in
CONCORD, NEW HAMPSHIRE
Boomer Memories from White's Park to the Capitol Theater

KATHLEEN D. BAILEY AND SHEILA R. BAILEY

THE
History
PRESS

Published by The History Press
Charleston, SC
www.historypress.com

Copyright © 2023 by Kathleen D. Bailey and Sheila R. Bailey
All rights reserved

First published 2023

Manufactured in the United States

ISBN 9781467154819

Library of Congress Control Number: 2023932350

This book is dedicated to my father and Sheila's grandfather.
Alfred Perron loved Concord. He was raised in a triple-decker on Rumford Street
and attended St. Peter's and St. John's, graduating from St. John's High School.
He served his country in World War II and worked at Brezner Tannery in
Penacook before striking out on his own as a freelance photographer.
For half a century, he chronicled his city, providing photos to the Concord Daily
Monitor *and* Manchester Union Leader, *shooting school and club and*
business events. We were fortunate to inherit his negatives, and I used many of his
photos to complete this book.
Dad, this one is for you.

Kathleen D. Bailey
2023

CONTENTS

ACKNOWLEDGEMENTS

In-depth interviews:

Ken Bly: his life in Concord.

Marc Boisvert: his life in Concord, courtesy photos and allowing me to use his Facebook group, "Concord, New Hampshire Now and Then" as a forum.

Paul Brogan: his life in Concord; courtesy photos and material from *The Concord Theatre* (Plaidswede Publishing, 2019), especially page 114; and moral support and encouragement.

Karon Devoid: her life in Concord.

Dolores Robbins Flanders: her life in Concord.

Royal Ford: his life in Concord.

Christine Prentiss Gifford: her life in Concord.

Ken Jordan: his life in Concord.

Paul Lillios: his life in Concord.

Omere Luneau; his life in Concord.

Sandy Pinfield Miller: her life in Concord, courtesy photos and moral support.

Ginie Murphy: her life in Concord.

Frank Perron: his life in Concord.

Mike Philbrick: his life in Concord.

Jim Rivers: his life in Concord.

David Sayward: his life in Concord.

Jim Spain: his life in Concord, information on the granite quarries and information on Cub Scout Pack 295.

Allan Stearns: his life in Concord.

Brenda Woodfin Thomas: her life in Concord.

Rick Tucker: his life in Concord.

Fred Walker: his life in Concord, courtesy photos and how to sneak into theaters.

Jim Wentworth: his life in Concord.

Also:

Celine Boucher: courtesy photo, Joseph Boucher.

Don Chase, Mom and Pop Stores of Concord, New Hampshire: photos and related material.

Ian Chisholm: Facebook and email material, Beatles haircut photo.

Concord Public Library Archives: Nevers Band and Rumford Press photos and allowing me to use the Concord Room.

Concord Monitor: permission to quote from an article, "Downtown Reimagined," in the "Around Concord" supplement, July 2021.

Tom Cusano: Dan's Hot Dogs photo.

Friends of the Audi webpage: information on the restoration effort.

Jeff Lewis: information on the 1960 Little League championship.

Jennifer Lane, New Hampshire DOT: material on Route 93.

Jeanne LaRosa: Millville photos.

Deborah Giles Lincoln: history and information on Nevers Band.

Ben "Bruno" Matson: Korner Kupboard photo.

Retired U.S. Navy Chief Master Petty Officer Richard Mudge: Facebook posts.

New Hampshire Preservation Alliance: information on the Gasholder.

Michael Cosgro: railroad station information, http://nashuacitystation.org.

Doug Spain: various material and reminiscences.

Ruth Speed: "Penacook Now and Then" Facebook page, Giant Store photos.

Janet Soden Sprague: Facebook posts.

I am extremely grateful for all the Concord kids who shared their memories with me. I'm thrilled at how open you have been and the color and variety of the stories you've shared. It *was* a special time.

I'm grateful to my editor, Michael Kinsella, for indulging me in one more crazy project.

I'm also grateful to my family: Autumn for tech support, Dave for general support and Sheila for providing photos.

It has been a wild ride but a rewarding one.

Introduction

THE LONG SUMMER

I don't go to class reunions. I have no axe to grind or any broken heart to avenge. I don't even care that they know I'm not a dork anymore. But I keep coming back to Concord, reaching for pieces of my past and trying to fit them into the greater puzzle. Growing up isn't linear; it's cyclical. You keep going back, at least in spirit, to see where you've been and how it affected where you are.

Concord has always been a city, but in our time, the 1950s and '60s, it was more like a glorified small town. And there were things that burned themselves into me: images, snippets of *being*, that are impossible to root out. Concord had a hand in making me who I am, in both a good and a negative way. Or as Frankie Valli of the Four Seasons said, "Girl, we can't leave the places where we were born."

Because it wasn't that big a city, if a city at all, we all had a lot of common ground. Saturday afternoon at the Capitol Theater, throwing popcorn at kids we didn't like from the balcony. Buying Beatles albums at French's Music Shop. Buying school supplies at Woolworth's, Newberry's or Kresge's. Watching the cashbox go up the wire at JCPenney.

Most of us wanted to get away: the preppies to college, the rest of us to anywhere else. We saw ourselves as tortured sensitive souls, stuck in a provincial backwater. Throw a rock and you'll hit Jack Kerouac, that kind of thing.

Most of us who wanted out got out, to college, the service or none of the above, and we found out what was "out there." "Out there" was good,

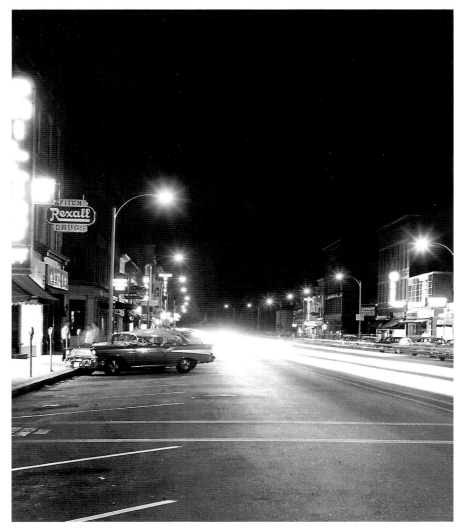

A photo of Our Fair City after hours. It looked pretty much like that in the daytime, too. *Alfred Perron.*

and it changed us. But some of us came back, or close enough that it didn't make any difference. By then, we knew that the "more" we wanted wasn't a physical place but a wider place in our hearts and spirits.

And we knew enough to treasure our memories.

Concord in the 1950s and early '60s had the state prison running at full capacity. There were no halfway houses. It had the state hospital running at

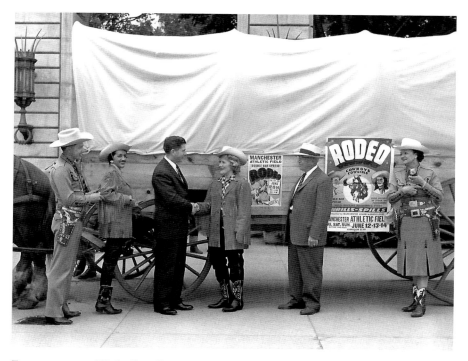

Former governor Wesley Powell accepts a tribute from the cast of a Wild West show to be presented in nearby Manchester. Chances are it *was* his first rodeo. *Alfred Perron.*

full capacity, too. Community-based mental health hadn't been invented yet. So we grew up around paroled convicts and released mental health patients, not to mention state reps and senators when the legislature was in session. Amazingly, we always felt safe.

Our fathers were home from the Second World War. Some talked about it: most didn't. Another war raged in a place called Korea, but it didn't touch us unless we had an uncle or a brother deployed. A little Black girl stood on the steps of an elementary school with an armed guard to see that she could get the same education as a White child, but it didn't touch us personally because we were almost all White. The House of Representatives focused on Communists with a laser beam, but that didn't touch us either. Or we thought it didn't.* Later, the assassination of a popular young president and a war in a distant land would shake us to the core, but for now, it was a sort of eternal summer, even in the winter.

* See chapter 9.

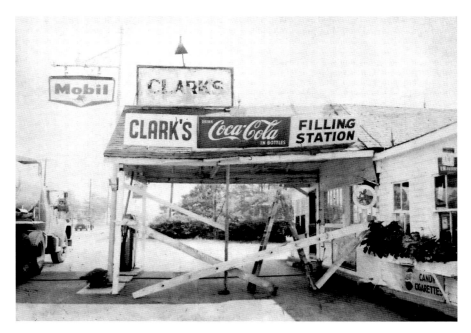

Ada Clark and her daughter Dorothy ran this store and gas station out of their home on the corner of Canterbury and Loudon Roads. *Alfred Perron.*

We skated on the rinks at neighborhood parks or went to White's Park for a proper skate house and piped-out music. We went sliding, without chaperones, on hills in our neighborhood that would eventually become apartment complexes. We picked blueberries in a patch that would one day become a pizza parlor and then a chain drugstore.

We walked to the neighborhood store. I lived on Concord Heights, its own spreading district on the other side of the river, and we walked barefoot to Towle's, Longley's, Frank and Bob's or Clark's. Clark's was operated by Ada Clark and her daughter Dorothy. They lived in the back of the store. Ada pumped the gas, even into her eighties, and Dottie, who was too fat to walk, ran the counter. Dottie had all the Heights gossip, and our mothers liked to visit while we pulled an ice-cold Coke or Sunkist Orange from the red-and-silver cooler.

When Ada died, Dottie went into elderly housing, and a Pizza Hut occupied their corner.

We had other "town characters": the man in the North End who kept exotic birds. "Franky Transistor," a young man who was a fixture around

Left: The iconic signage on the corner of Phenix Hall managed to survive two tries at urban renewal. *Alfred Perron.*

Below: We drove cool cars. *Alfred Perron.*

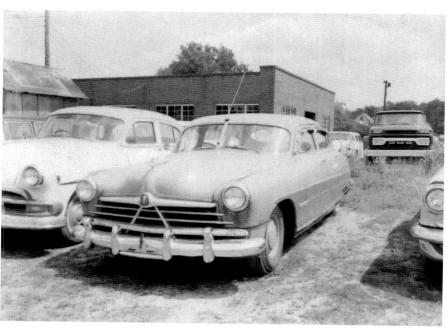

town, with his transistor radio pressed to his ears.[*] The one-hundred-year-old Salvation Army woman who set up camp in front of Woolworth's every December. It was a world where characters flourished because there was nobody to tell them that wasn't the way to be.

It was the kind of world where Theresa Cantin, owner of the Concord Theatre, would mother everyone who came through her door, from patrons to projectionists. The theater stood next to the Friendly Club, an old Victorian house where young women could rent rooms. The "girls" from the club often cut loose on Friday nights with a movie at the Concord, and sometimes said movie would run late. According to Paul Brogan, author of *The Concord Theatre*, "Theresa would call Elsie Campbell, the matron at the Friendly Club, to let her know that the girls were all right."

It was that kind of town. It was that kind of world.

Some of us suspected that another world existed. The rich kids, who lived on the Hill, did some traveling. The rest of us went to the library, or the bookmobile, and learned about a world outside of Concord. My friends and I took the bus to Manchester, for the princely sum of one dollar, so we could ride the escalator at Pariseau's Department Store. We were such rubes. Paul Brogan suspected another world, and he would take the bus to Manchester and bribe the desk clerk at the Carpenter Motor Hotel so he could ride the elevator to the top. Paul saw that other world, soaring above the factories and tenements.[†]

The outside world would eventually come to us, battering its way in.[‡] We and the nation would be forever changed. But for now, it was summer, and we reveled in it.

Note: For the purpose of this book, I will refer to Concord's grande dame of parks as White's Park. Mike Philbrick also continues to use the possessive, saying, "Don't give me that 'White Park' stuff."

[*] See chapter 8.
[†] Paul Brogan, in conversation, 2022.
[‡] See chapter 9.

Chapter 1

THERE GOES THE NEIGHBORHOOD

I n hindsight, we were sheltered," Karon Devoid says. "But we didn't
know it at the time."

That about sums it up.

The North End was the closest we had to an ethnic enclave, with
clusters of Irish, Italian and French Canadian families. Swedes and other
Scandinavians tended to settle in West Concord so they would have an easy
route to the granite quarries. Families of means gravitated to the Auburn
Street/Ridge Road area. We may have come home at night to souvlaki,
spaghetti Bolognese or smorgasbord, but we wore the same Villager shirts
and skirts. We listened to the same albums or danced to them at the Friday
night community center sock hops. We styled our hair the same and flocked
to the same Disney matinees on Saturdays. *Diversity* wasn't a word in our
lexicon. There was nobody to be diverse with.

Bus service was sporadic, so the neighborhoods were our nuclei, at least
in the early years.

HEIGHTS

I grew up on the Heights, a broad plateau of undeveloped land on the other
side of the river, if not the tracks. Loudon Road (Routes 202 and 9) was the

main route to Dover, Portsmouth and the seacoast, yet we could stand in the center of the two-lane for up to ten minutes without seeing a car.

Karon Devoid, now seventy-three, was born in Manchester but moved to Concord with her parents and twin brother, Kirk, when she was three. Like many Concord families, they came because the granite industry offered work. Her father worked at a granite quarry behind the old Fosterville neighborhood until he had a chance to buy a granite business on Little Pond Road.

"He sold monuments, and my mother sold life insurance," Devoid says, adding that hers was one of the few families in town where both parents worked outside the home.

In Concord, the Devoids first lived in a duplex across from Boutwell's Bowling and then moved to their home on the Heights, next to the Tom Collins store on Loudon Road.

"I thought it was awesome," Devoid says of the area known as the Plains or, less charitably, Burglar's Island. Tom Collins was at the end of what passed for a commercial district in those times, a motley collection of corner stores and small businesses run out of smaller frame houses.

They walked everywhere, Devoid said. The family was Catholic, and they walked to the new Immaculate Heart of Mary Church. Near their home were a small motel and a lowlife bar that was emphatically off-limits to the Devoid kids. But they hung out at the motel from time to time, and Karon remembers a woman and her husband visiting for the summer. They had a chimpanzee, Devoid says. "It was in jeans and a T-shirt," she recalls, "and I was fascinated."

Dolores Robbins Flanders also enjoyed her time on the Heights. She lived across the street from the Heights park and pool and remembers going in after hours. In the early years, she didn't even have to hop the fence—there wasn't any.

Flanders roamed the countryside on her horse, Rebel, and by bicycle. She remembers an old, old man with the unfortunate last name of Cabbage who lived in a shack near the end of Chase Street. Flanders and her cronies would ride their bikes down to Chase Street and Branch Turnpike, where they hoped to get a glimpse of the man. He was an alcoholic and, she recalls, was rumored to strain antifreeze through white bread to get his alcohol.

There were other simple pleasures, such as poking around a supposed haunted house where the Department of Motor Vehicles now stands, Flanders says. "We would lie on our tummies in the grass and watch the wind move the curtains and say it was ghosts."

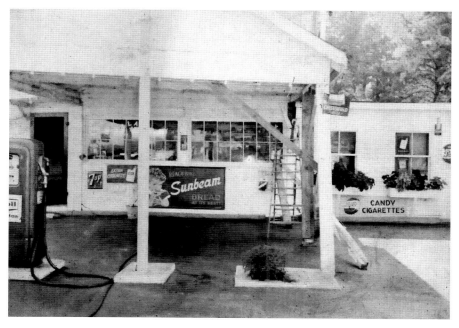

The corner store was a gathering place for kids with allowances and housewives who didn't drive. Another view of Clark's! *Alfred Perron.*

The young Flanders was never at a loss for candy or a quick bottle of soda: her father had a tab at Towle's Market, and he settled up at the end of each week.

Jim Wentworth, sixty-eight, grew up on the Heights, though he now lives in Troy, Vermont. The CHS graduate of 1971 was raised on Lawrence Street, off Airport Road.

His father, Fran, operated a commercial printing firm, Wenday, out of his home. Fran and his wife, Edna Myrick Wentworth, had Jim in the old Memorial Hospital on South Spring Street. Edna Wentworth was also a Heights native, growing up on Old Loudon Road, according to Wentworth.

The Heights was a self-contained community in Wentworth's childhood, with a half-dozen mom-and-pop stores. "You knew everybody, you trusted everybody." He went to Dame School for kindergarten through sixth grade.

Wentworth remembers Clark's Store on the corner of Loudon and Canterbury Roads and the feel of a cold soft drink on a hot day. "They had this top-loading Coke cooler, and the soda was cooled in cold water," he said. "The bottle dripped when you pulled it out." He also remembers Longley's,

on the opposite corner from Clark's, and Towle's, Frank's (later Frank and Bob's) and the Heights Market.

"Mom-and-pop," he says, "was the best thing ever to happen to business."

Jim Rivers was raised in the South End until he was thirteen, when his widowed mother moved the family to Branch Turnpike. The Heights was still fairly rural, with only half of Dudley Drive completed. "I could see deer across Loudon Road," Rivers recalls.

His parents were Steve and Jean Rivers, and he had three sisters: Sandra, Theresa and Jacqueline, the latter by his mother's second marriage.

Rivers spent his early years in the South End on Monroe Street. His father was killed in a construction accident when Rivers was nine. Steve Rivers was the foreman for the electrical division working on the General Sullivan Bridge in Newington. "He was putting the lights up, the crane broke, a beam came down and he was hit in the head," the younger Rivers recalls.

But Concord, he said, was a "great place to grow up in," in either of his neighborhoods.

Kids stayed closer to home then, and the younger Rivers never met kids from other neighborhoods until junior high. It was a great thrill for him to ride his bike from the South End to his aunt's house in the North End.

In both neighborhoods, traffic was slow, if it existed at all, and Rivers would play pick-up football and baseball in the middle of the street. There were no uniforms, "and we played outside till it was dark," he says.

Royal Ford's trajectory would take him to executive editor of the *Boston Globe* before retirement in Portugal. But for his early life, he, too, was a Heights kid, living in a "tiny ranch house" on Branch Turnpike. Born in 1950, he was part of the generation that roamed the sparsely settled plateau from the park to Longley's Store to Clark's to Tom Collins, where he turned in glass bottles for cash. He attended Dame School for grades one through five before living briefly on Hall Street and eventually moving to Hopkinton.

"I do remember roaming the woods on the Heights, very piney, and Heights was still pretty barren back in the '50s," Ford wrote in an email. "We could roam all the way across Pembroke Road and on to the airport." One of their destinations was an old airplane frame in the woods, on which they played with no one concerned about their safety, according to Ford.

Ford also remembers less savory aspects of Heights life. "I remember walking through the woods between Branch Turnpike and Dame School

and seeing old guys—'drunks,' my parents called them—hanging out in the woods, drinking beer and what my father later explained was 'canned heat'—a paste taken from cans and mixed with water."

NORTH END

There's no real controversy about "White Park" versus "White's Park," at least if you're from a certain generation. But opinions differ as to where the North End begins. Some loop in the White's Park area, while others define their North End as strictly Fosterville, the area just before the cemetery.

Paul Brogan, now seventy-two, was adopted and brought home to a house on Franklin Street, but his family soon moved to Academy Street, in the North End. Brogan remembers the Academy Street area as a close-knit neighborhood. The United Life Insurance Company stood on the corner by White's Park. It is now the University of New Hampshire (UNH) Law School. His mother shopped at the Food Basket. And neighborhood boys got their hair cut at George the Barber. "He specialized in the 'fuzz ball' haircut, and every kid in the neighborhood got one," Brogan recalls. "It was the only style George seemed to know. We looked like a 'Stepford neighborhood.'" The cut was given once after school let out, and boys were scheduled to get another one before school opened in the fall.

Brogan got sick of it after a while—literally. "I feigned illness for the last two weeks of August. I didn't want to go back to school looking like an alien."

Sandy Pinfield Miller was also a North Ender, spending all her young life in a duplex on Lyndon Street, near a corner of White's Park. "We called it 'White's Park,'" she says, noting that the name has changed over the years.

She attended Walker School for grades K through six. "Back when we were kids, there were so many elementary schools in Concord," she recalls. "We all walked to school."

In junior high and high school, Miller learned she lived two houses over from the termination of the school bus line, so she also walked to Rundlett and Concord High. She picked up friends along the way, and the journey was, if long, not lonely.

Miller's father, Bill, worked nights at the Rumford Press, and her mother, Annie, also worked, first at W.T. Grant and then for a friend's rubber stamp

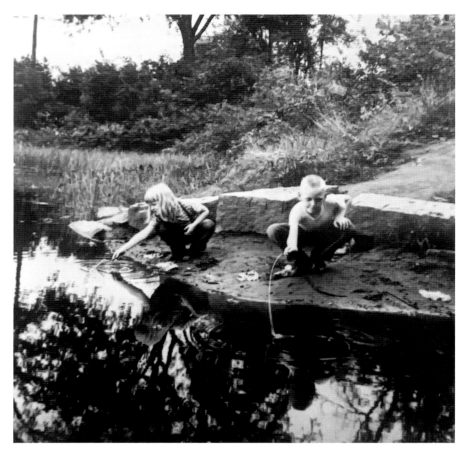

Ponds, rivers and streams were accessible by walking. Sandy Pinfield Miller and her brother Jim explore nature near their Lyndon Street home. *Sandy Pinfield Miller.*

business. Annie eventually got a job at J.J. Newberry's, one of four five-and-dimes on Main Street, and she stayed there till retirement. They did not buy a car until Miller was a senior in high school but walked to work and everywhere else.

Miller and her brother rarely saw a babysitter, even though both parents worked full time. Her father worked nights at the Rumford, so he was available for both children after school and also started dinner. "He worked until 2:30 a.m. My mother got off at 4:30 p.m.," Miller says.

With two working parents on two different shifts, her parents rarely went out, Miller recalled. Their social life revolved around the Concord Camera Club, which met in the old clubhouse at White's Park. When they did have

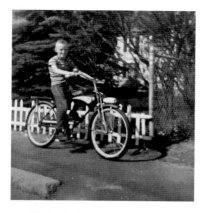

Jim Pinfield tries out a new bicycle near his Lyndon Street home. *Sandy Pinfield Miller.*

an event sans children, Miller and Jim were cared for by an elderly neighbor, Mrs. Grinnell.

The Pinfields were unusual for the time in that they never bought a house but rented half of the Lyndon Street duplex. They didn't own a car until Miller was a senior in high school. So her world was more limited even than most Concord children's. "I see these posts on reunion sites about Janet's Donuts," she says. "I never went to Janet's. It was in the South End, and we didn't have a car. I never went to Polly Susan Bakery or Keniston's [a clam stand by the river]."

Miller adds, "We did not eat out. I didn't realize there was a whole big world in Concord." When she was in the second grade, her father mentioned moving to the South End, and Miller cried because it seemed so far away. They stayed on Lyndon Street.

"The North End," Miller says, "was a great place to grow up." She bought her penny candy and did errands for her mother at the Quality Cash Market, one of several neighborhood stores dotting the city. She had a best friend, Lynn Vintinner of Jackson Street, and felt "adopted" by the Vintinners' large family.

Jim Spain, sixty-two, never wanted to be anywhere else. Spain grew up near White's Park. His family emigrated from Ireland and eventually settled in Concord's Fosterville neighborhood. They were indentured servants who first went to Manchester and then landed in Concord to work in the granite industry. There were aunts, uncles, cousins and his father, James W. Spain, who went by the name of Bill. Spain's father was a state trooper.

While the family had strong roots in Fosterville, Bill Spain wanted to raise his children closer to White's Park, so he bought a house on North State Street. But Fosterville was only a short walk away, so young Jim made the trek often to visit with grandparents, great-grandparents and whoever else was around. It was a multigenerational neighborhood, he said, and all the families knew each other—the Irish, the French Canadians and the Italians. "That fabric," he says, "made me what I am."

Young Jim had a paper route delivering the *Concord Monitor*, at that time an afternoon newspaper. He would pick up his papers at the old trolley stop

at White's Park and deliver them on a "black Schwinn bicycle with twin baskets," his pride and joy. "I bought it myself," he says. "It was a Stingray, and it had three speeds."

Jim picked up the *Monitor*, cut the string and counted the papers. His first stop was the United Life Insurance Company, where he had twenty-two customers. "I dropped the papers on everyone's desks, then I went to the cafeteria and had a doughnut and an orange soda," he recalls.

Then it was on to his residential customers. He remembers every name and every house where he delivered. "Mr. Robinson lived across from the park, and he was about ninety," Spain recalls. "He always said, 'Have a seat, Jimmy,' and his wife would bring me an iced tea. We'd sit there and look out at the park." Mr. Hackett was a prison guard, and young Jim made extra money shoveling his driveway.

Jim's father's hopes for his children and White's Park were fulfilled, with James and his siblings skating or swimming almost every day. "When he bought the house, my dad said, 'It's the best backyard in the city.'" James and Richard could always find a pick-up game of basketball or hockey.

Mike Philbrick was born in 1957 as part of a large Irish clan in the North End. His grandparents also lived in the Fosterville section, and his parents grew up there before settling down on Tremont Street. When he was in junior high, his parents moved to the Heights and a house on Airport Road.

His grandmother was French Canadian, his other relatives were Irish and he grew up with both nationalities, Italians and a few Greeks. He got his penny candy and soda at the Quality Cash Market and the Food Basket.

Where did he play? "White's Park," he said. "Always White's Park."

There were sledding and skating in the winter, swimming and pick-up games in summer. In the winter, Philbrick played basketball at the old Boys' Club building and also with St. Peter's CYO team.

Central

Fred Walker, seventy-five, was born in the old Concord Hospital on South Spring Street and spent his early years in Fosterville. He says the neighborhood was the toughest in Concord, including the kids from three tenement blocks across the street, and he had no regrets when his family

moved to Prince Street, between city hall and the Concord Public Library. That was like "paradise" compared to Fosterville, Walker says.

He was still able to hang out in White's Park, with kids he's in touch with to this day. In summers, he would get up, go to the park, come home for lunch and go back to the park. He'd come home for supper, and then it was "back to the park" again.

"West End"

Frank Perron was born at the Elliot Hospital in Manchester in 1945. His parents moved to Concord, and he first lived on Duncklee Street in the South End and then moved to 210 Pleasant Street, at the junction of Pleasant and Kensington, in 1951 or '52. The neighborhood was called the West End, to be distinguished from West Concord.

At the center of the West End was the West End Market, operated by the Guerrero family. The store burned down one evening, "and the whole neighborhood came out to watch it burn," Perron says.

The West End in Perron's time was "pretty quiet. It was a residential area. Across the street, there was a huge field with a radio tower in the middle." He knew most of the kids in his neighborhood.

West Concord

Paul Lillios's roots run deep to the North End and the West Side. He was raised on Chapel Street and currently lives in West Concord. Lillios, now sixty-three, said when he was growing up, the town was both "small enough" and "big enough." "It had most of the things you wanted," Lillios says.

Lillios remembers fishing in Horseshoe Pond, riding his bike everywhere and dogs without leashes. "The town," he says, "was user-friendly."

Ginie Murphy, sixty-eight, was born at the Portsmouth Naval Shipyard hospital when it was still Portsmouth, before Kittery claimed the facility. Her father was in the service and stationed there, although he had retired by the time she was born. Her father's name was Gilbert Murphy; her mother was Marie Marguerite, known as "Margaret"; and she had an older brother named Bill.

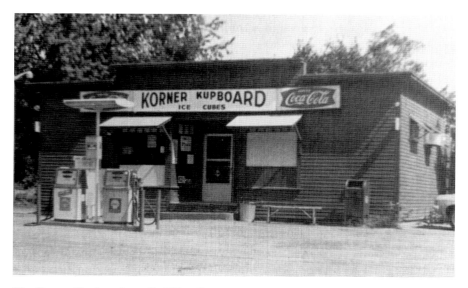

The Korner Kupboard supplied West Concord's needs for decades. *Bruno Matson.*

The family lived briefly in Alton and moved to Concord in 1956. It hadn't been their original plan, but after her father had a car accident, there was a brief period where he couldn't drive. He had to work, and he had to be able to walk to work, so he took a job at the New Hampshire State Prison in the boiler room, and the family got an apartment near the prison, later purchasing a home.

Murphy remembers several of her neighbors being Swedish or part Scandinavian. They came to Concord to work in one of the many granite quarries.

But Murphy had more of a Penacook orientation than a strictly Concord one. "I was living at about the end of the Concord School District," she says. Her neighborhood on Windsor Avenue was small. "When we moved there, there were only three houses." Then the Church of Christ was built at the end of the street. But in the early years, she remembers, "there weren't a lot of 'neighbors' in the neighborhood."

In the summer, Murphy and her friends walked or rode their bikes to Garrison Park. "We swam all day and rode our bikes home," she says. Occasionally, she'd bike or walk to Rolfe Park instead, over the Penacook line.

Children who lived near River Road ended up swimming in the river, sans lifeguards, she observes. She still sees people on the river, in small boats.

East Concord

Allan Stearns was born in Lebanon and moved to East Concord in 1955, in time for third grade. He went to Eastman School before the redistricting that sent Portsmouth Street kids to Dame School and ultimately to the Mill Brook School, a consolidation of Dame and Eastman. But in those days, neighborhood schools reigned. Stearns, his parents and one brother lived on Portsmouth Street. They had one acre of land, but it didn't matter—their land bordered woods, and he frequently took his .22 rifle out to shoot at tin cans. East Side Drive bordered the Merrimack River, and the Stearns boys often crossed the road to roam the bluffs. East Concord also had a public park with a pool and baseball field, so there was plenty for a young boy to do.

Though schools were smaller then, classes were bigger, and Stearns remembers thirty children in his sixth-grade class at Eastman. That's nothing, he adds: his school in Enfield had forty-eight children in his class.

He and his best friend, now *Nixon in China* composer John Adams, also used to play in the backyard of Bridges House, the official residence for New Hampshire's governors.

There was some culture shock when Stearns went to Rundlett, but not much. The kids there wore the same clothes as the East Concord children; they had the same haircuts. "There were just more of them," he says.

Ken Bly didn't spend a lot of time playing in vacant lots around the city. He didn't have to: his family owned a one-hundred-acre dairy farm off Mountain Road, and he and his younger brother, Peter, had all the amenities.

Rockview Farm was built in 1860 and supplied milk to Weeks Dairy and the Hood company. The young Bly had chores at an early age. "We were either doing chores or getting in trouble," Bly, now sixty-nine, recalls.

Or both. "When my brother and I were arguing, we'd throw hay at each other. Not handfuls. Bales," Bly says cheerfully. He also has a scar inside his right knee where Peter "took a pitchfork to me," he adds.

The Bly farm was multigenerational, with his grandparents living out their lives on the property and a boarder who stayed on until they sold the farm. In an early nod to agritourism, the farm also hosted wealthy Bostonians in the summer, he says.

Bly fished and hunted, skied on the country club property and learned to play golf. While other kids have tales of hanging out downtown, Bly didn't go to town that much. "I was mostly on the farm," he says. Which was enough.

The Bly kids and their friends used to sled from Rockview Farm to the railroad tracks. The federal government bought up several acres to build I-93, and Bly remembers watching the heavy equipment crews as they graded the hill. But he still had plenty of woods, fields and hills in the East Concord of his day.

The family were also early users of the snowmobile, and Bly remembers his mother, an Avon representative, suiting up to deliver her orders by snow machine.

East Concord also had the dubious distinction of the funniest nickname for a neighborhood. It was dubbed Peckerville in honor of the monument to Colonel John Pecker at the junction of Mountain and Shaker Roads. It's the kind of thing you can't make up. The monument was sacrificed in the building of I-93. It wasn't urban renewal but rural renewal.

South Central

Marc Boisvert defines his stomping ground as "South Central," and he's had seventy-one years to think about it. "I measure my neighborhood as Pleasant Street, South Spring Street, West Street and South Main Street," he says, adding, "We moved a lot, six different places, but they were all in South Central." His father, Ray, worked a variety of jobs, and his mother, Irene, was a registered nurse at Concord Hospital. His brother, Marty, was two and a half years older.

Sacred Heart Church was the Catholic hub for the neighborhood. Boisvert's entire family attended Sacred Heart, going back to his mother in the 1920s. "My grandparents donated a stained-glass window," he recalls.

The Boisvert children were actually not allowed to play with non-Catholics, so "everybody I knew was Catholic," he says.

The South End (Gashouse Gang!)

Pat Hannaford Shearon grew up on Noyes Street. Shearon remembers playing pick-up baseball in the streets, clearing out when the cars came. Southies slid down the Noyes Street hill on sleds and skated on a makeshift rink behind Giffords' Store on Broadway. Shearon patronized Rollins Park

and remembers summers and the five-cent ice cream cones at the Dew Drop Inn on Clinton and South Streets.

Jim Rivers spent his early childhood in the South End. He was a parks kid, playing wiffleball at the Fayette Street park and other games at a small park on West Street and finally roaming Rollins Park, the anchor park for the South End.

A class structure was in place, and we learned it when we ventured out of the neighborhoods and on to Rundlett Junior High School. Many of our contemporaries sensed a divide between the kids from Auburn Street and Ridge Road, the so-called Hill, and the rest of us. Karon Devoid chose to raise her daughter in Penacook so she could go to Merrimack Valley High School, which offered more diversity with its five feeder towns. Though Frank Perron's father was a doctor, like many of theirs, Frank felt estranged from the "Hill kids." And Fred Walker's frustration with the Hill phenomenon led to his choice of Bishop Brady over Concord High.*

Not all was *Mayberry* cozy. Paul Brogan agrees. The Concord kids at Bishop Brady, our local Catholic high school, tended to snub the students who came in by bus from Suncook, Franklin, Laconia and Tilton. The children who lived on the Hill tended to keep to themselves, he observes.

But Concord also took care of its own, Brogan adds.†

Ian Chisholm moved to town when he was three, and after a short time in a duplex, his parents bought a home on Chestnut Court off Auburn Street. Chisholm wrote in an email,

> *I was oblivious to being lucky enough to live on the "Hill," and I never heard that term used until I was seventeen. It was at my summer vacation job where a woman wagged her finger at me and said that, "I know you! You live up on Mortgage Hill." I had so many friends who did not live on the Hill, that I didn't really understand why I should be embarrassed about where I lived. Looking back now, I realize that I was mostly insulated from the financial difficulties that a lot of people struggled (and continue to struggle) with on a daily basis. Whenever anything broke in our house, my parents would "call the man" to come fix it. It didn't occur to me that other people fixed things themselves.*

* See chapter 3.
† See chapter 8.

But Chisholm never isolated himself, writing, "I met a lot of friends who all lived on the Hill, but when I went to Kimball School I met kids who didn't live on the Hill, and I made quite a few friends."

Doug Spain worked as a White's Park lifeguard and met kids from all walks of Concord life. His perspective: "I worked with many kids from the Hill as a lifeguard for Rec and Parks, for four years. They were great kids, and many have remained good friends to this day."

Spain adds that it's all a matter of perspective. "As one travels and evolves educationally and financially, one identifies 'the Hill' as a middle-class neighborhood, as seen in most cities. Nothing special. It's all relative."

Susan Brown Sommer agrees, writing on Facebook, "I lived on Upper School Street where all the doctors and lawyers lived. We were no different from anyone else, just because some had money." Her stepfather was a prison guard, Sommer writes, adding, "Everyone is different and it doesn't matter where you live."

Janet Soden Sprague also grew up on upper School Street. She wrote on Facebook, "I can't think of anyone who was a snob. We all had friends from other parts of the city. We also had friends from Bow, once we were in high school."

I personally got along with some of the Auburn Street kids and not with others. I got along with some Heights kids and not with others. Doug Spain comes the closest to my point of view when he opines, "It's a matter of perspective."

Omere Luneau never quite felt that he fit in anywhere in Concord, over Hill or over dale. His parents were artists, health-food enthusiasts and environmentalists, way before their time. When he was three or four, Luneau recalls, his parents bought a building on Chapel Street and opened Luneau's Life Foods. While other kids were chowing down on hot dogs and Twinkies, the Luneau brothers were enjoying carob birthday cakes and their parents' campaigns. "My dentist used to give us a coupon for a free ice cream at Fortier's Pharmacy," Luneau recalls. "My father would call him up and say, 'Don't you know that sugar rots teeth?'"

The senior Luneaus were on the forefront of the environmentalist movement. "When my father heard that the town was going to spray DDT, he got the neighbors on Chapel Street to sign a petition," Luneau says. "The town didn't spray Chapel Street. But they did spray Washington, Court and Pitman"—all Concord streets the family used to get home.

Luneau allows that his parents may have been "a little eccentric," especially by fifties standards. It didn't help that they gave him an unusual

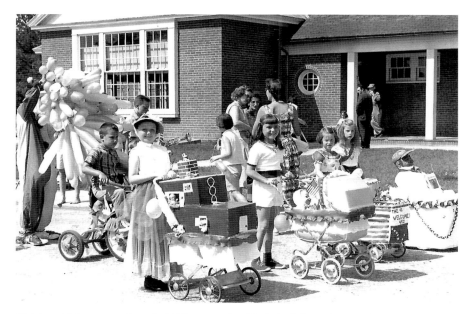

Heights children turned out in 1961 to march with their doll carriages and bikes in the Fourth of July parade. We celebrated the creation of a country where only White people were free, but White people were the only people we knew. *Alfred Perron.*

name, Omere, instead of Bobby or Billy. And it didn't help him blend in when he began to form his own opinions about religion, politics and the world around him. "I have," he says now, "no filter."*

Like many Concord kids of the era, Luneau had "my upbringing at White's Park." He met many kindred spirits there, kids he's friends with today. But he spent more time at Doyen Park, nearer his home and named for a World War I hero, Brigadier General Charles Doyen. It is now a parking lot, he said, and the memorial to Doyen has been moved to a corner of the old Superior Court building. "We used the memorial for a backstop for baseball," he said.

The neighborhood was close-knit, with what passed for ethnic diversity in the fifties: some French, some Irish or Italian and a few Greeks. "We melded," Luneau said.

He remembers picking up prescriptions at Fortier's Pharmacy and playing pinball with the town's first pinball machine at Central Taxi. Kids cut through the VFW parking lot to get to Fortier's and Main Street. "One time, we found a monkey skull in the parking lot of Stevens' Diner," Luneau says.

* See chapters 3, 9 and 10.

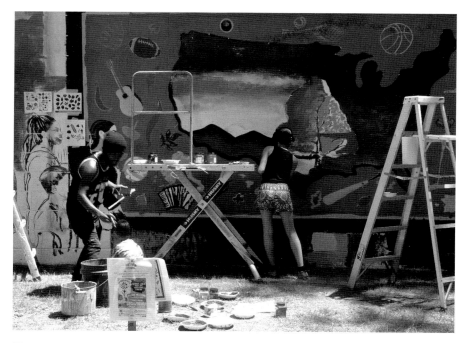

The twenty-first century saw a sea change in the makeup of Concord neighborhoods. A wave of immigration brought in people who didn't look like us, talk like us or even dress like us. Most of the new arrivals settled on the Heights, in Royal or Concord Gardens, and they changed the character of the once-White neighborhood. Asian and African groceries replaced the tired corner convenience stores. The city now celebrates its diverse cultures with a multicultural festival, usually in September. And Keach Park, home base for bored Heights kids, now sports a mural celebrating the diversity of today's Concord. *Kathleen Bailey.*

He cashed in his empty glass bottles at the Highway Hotel, which gave him five cents for each.

Kenneth Bly grew up next to the Concord Country Club and spent much of his free time playing golf. He was able to meet the Hill kids on their own turf, competing against them in tournaments. Though he perceived a gulf between him and the "elite" kids at school, it vanished at the club. It was a level playing field, at least in a metaphorical sense.

There were pecking orders in neighborhoods, too. Most of the Heights kids in my generation were afraid of Darlene Plodzic, though nobody could pinpoint what she actually did. Darlene Plodzic was like Fonzie. She just had to stand there, and you started to quake. At some point in elementary school, she vanished from the Heights forever. I like to think she retired to the Cayman Islands with the lunch money she took from us.

The city was to evolve over the years. With the Age of Aquarius, she didn't have a choice. Families of every ethnicity found the quiet town by the river a good place to raise their little ones, and Concord opened her arms wide to refugees, most of whom settled on the Heights. They added their flavors, their fashions and their customs to Concord and the Heights. The city now has a multicultural festival every year, usually in September and usually in the Heights' Keach Park. It was a long road to travel, but we got there.

Chapter 2

FOR WHOM THE
(SCHOOL) BELL TOLLS

Ken Jordan remembers just how it was. He and his sisters would set off from their West Street home for St. John's School on South State Street. Along the way, other kids would "peel off" from their homes and join the little procession. The group snowballed as they walked, and Jordan recalls as many as a dozen kids making their way to St. John's together. "Everyone knew everyone else," Jordan says.

We dressed in ironed clothes, walked the block or two with friends and filed in as the bell rang. We copied our homework or penmanship lessons from a blackboard, pencils scratching against lined paper. We ate our morning snack and drank our bottled milk under the watchful eyes of Washington, Lincoln and Ike. We lined up to go in and lined up to go out, our starched plaid dresses rustling against the wooden desks. The worst punishment for breaking this new world order was standing in the hall, and it usually worked.

School ordered our lives. If you lived in an organized household, it was an extension of home. If your home was more chaotic, it gave you structure. The same things happened every day, in the same order, regimented by bells. Catholic school had its own rituals and discipline, but public schools weren't far behind—just a different uniform.

We got to memorize. A lot. States, state capitals, the map of Europe and its capitals. History was separate from geography, and we would be in junior high or high school before we understood how one affects the other. We learned geography without culture and history without context. We were on board for the statehood of both Alaska and Hawaii. Alan

Shepard's first foray into space brought the country together, and we watched it on an already outdated black-and-white TV, with one of the teachers holding the antenna.[*]

We learned the legends of Washington and Lincoln, again without much context but with the moral lessons our teachers thought we needed. Washington told his father he couldn't lie, and Lincoln walked miles in the dark to return a book. We colored cherry trees in February and the Niña, the Pinta and the Santa Maria in October. Columbus was a good guy, and because we lived in the North, the Civil War was righteous and holy. We learned about slavery but very little about the rest of Black people's tangled history in our country.

We had fire drills and air raid drills. Several times a year, we were guided from the classroom to sit on the floor in the hallway—there went my starched dress—and put our heads in our hands. It was our bulwark against a nuclear attack, most likely from Russia. Many of our dads had fallout shelters in the basement, so it made sense.

We had plays, concerts and recitals on a tiny stage in what doubled as a cafeteria.

My school, Dame School on the Heights, ran on a shoestring. Our music book had Civil War songs, and I got speech therapy once a month in a corner of the small stage. We didn't know about autism, dyslexia, ADD or ADHD. Students with what would eventually be called "special needs" went to their own school, the Morrill School, downtown. Children and adults deemed not able to learn anything were shipped off to the Laconia State School. It would take Eunice Kennedy Shriver, angry parents and something called the ADA to give these children a better chance.

Paul Brogan barely made the cutoff date for kindergarten, but once in Walker School, he felt right at home. "It was a true neighborhood school," Brogan remembers. "We interacted at the park, at church." His teachers were like "ethereal beings," he said, beautifully dressed and made-up. He also liked rest time, fifteen minutes every day, when they received ice-cold glass bottles of milk from Concord Dairy.

The smell of erasers and chalk was comforting to Brogan, and though he started school at age four, he felt safe on the five- or six-minute walk home. He later attended Kimball School before enrolling in St. Peter's parochial school.

Kimball was one of the oldest schools in the city, and Brogan attended the year before it was torn down. In that final year, the first grade was held in

[*] See chapter 8.

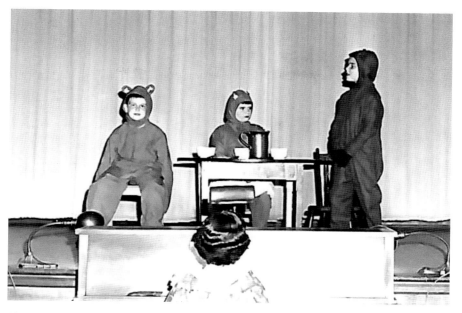

The Three Bears, Dame School class play. The late Dougie Cailler was adorable as Baby Bear. *Alfred Perron.*

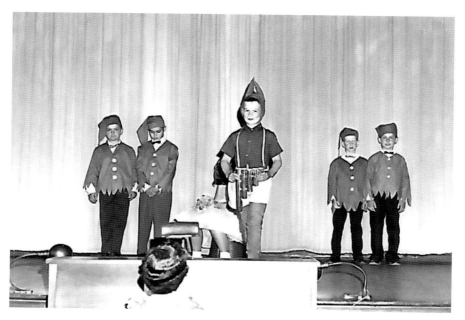

Dame School play. Alan Drew with panpipes. *Alfred Perron.*

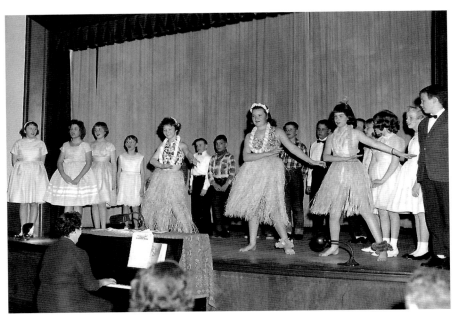

Dame School play. I think this one was a salute to the fifty states. Had to get an executive decision from the principal and the Harper Valley PTA before the girls could show midriffs. Ah, the fifties… *Alfred Perron.*

the basement, next to the boiler room. "When the boiler came on, it would shake the classroom," he says. He again liked his teacher, a Miss O'Mara. He continued to appreciate the elegance of the teachers in the fifties, who wore makeup and dresses.

He also enjoyed the reading block at the end of the day, when the teacher would read aloud from classics.

The wrecking ball came to Kimball, and the spot was empty for some sixty years. It was finally replaced with a playground at School and Warren Streets. When Brogan was in second grade, Rundlett opened, and the old junior high building was revamped into the "new" Kimball School.

RULES AND RULERS

Though Catholic School clichés abound, Brogan says the Sisters of Mercy at St. Peter's were, well, merciful. Or relatively so. "I never," Brogan says, "saw anyone hit with a yardstick. But they could be—acerbic."

Brogan found that the students in the smaller school were ahead of those at the public schools he'd attended. The class was writing in cursive, and Brogan wasn't. "I was still printing in third grade," he admits. "Sister Mary John noticed it and said she wasn't going to allow me to 'hold back' the class." Brogan remembers blushing and wanting to crawl under the desk— "but I couldn't. It was attached to the floor," he explains breezily. He did master cursive and catch up to the class, he adds.

Discipline was expected, but as long as a student got an A in "conduct and religion," they were OK, Brogan recalls. St. Peter's held to the barbaric custom of having the priest, or the highest authority in the school, present the report cards and comment on them in front of the whole class. "For us, it was Monsignor Sliney," he says. Brogan did well and was never embarrassed by the priest.

The Sisters took care of the hands-on discipline, and though children rarely offended, the nuns had a unique punishment for those who transgressed mightily. "We had these coat hooks in the hallway," Brogan says. "If a child offended, Sister Mary John would go upstairs and fetch Sister Theresa, the seventh-grade teacher." Sister Theresa would come downstairs, take the offender by the ear and hang them by their belt from the coat hook for one hour. "She would say, 'Remember Christ on the Cross,'" Brogan says, adding, "They never offended again."

Ken Jordan, who went to St. John's School and High School, has a slightly different take on the discipline. "You hear all the bad stories about the nuns," Jordan says. "Well, we didn't give them an awful lot to work with. We were all from large families, and we had to elbow each other to the dinner table." Jordan diplomatically describes himself and his classmates as "a little rough-and-tumble."

The Sisters also had fewer physical resources than teachers at the public schools, and Jordan remembers their midmorning snack being surplus powdered milk. But the kids, fresh off wartime and rations, drank it gratefully.

Brogan's classroom featured a statue of a little Black child with his head bowed. It was actually a bank, and on Fridays, children were encouraged to put what was left of their allowance in the bank, "to save the pagan babies in Africa." The canny Brogan learned to leave his allowance at home.

There was an emphasis on memorization, not too different from public schools at that time, and Brogan remembers drilling on state capitals for his fifth-grade final exam. There were only forty-eight, he adds. Spelling was

emphasized with drills and bees. "If you won the spelling bee, you got a holy card," he says. Kids who came in last also got a holy card, with a picture of the flames of hell.

And of course, the kids were shepherded to confession once a week.

By the time Brogan got to Bishop Brady, things had loosened up, both because of the Age of Aquarius and because the male students were bigger than the nuns. There would be no more hanging from coat hooks. The nuns showed more respect for the students, with his French teacher, Sister Mary Alford, calling him Monsieur Brogan. The Latin mass had been replaced with the folk mass, nuns' habits were on the way out and the Sisters were going back to their given names.

Jim Spain was eager to go to school. When he was five, his parents brought him over to St. Peter's, but the nuns explained that they didn't have a kindergarten and he would have to wait.

He was finally old enough for first grade, and his parents told him, "Walk to school with Richard [his older brother]. When the bell rings, go inside. And when the bell rings again, come home." The bell was a literal bell, swung by a Sister of Mercy in flowing black robes.

Perhaps because of limited staff, perhaps because of limited space, perhaps because they were ahead of their time, the Sisters put two grades in one room: first with second, third with fourth and fifth with sixth. Some of the kids were bigger than Spain, but they didn't bother him.

Spain found he loved school, except for one aspect: penmanship. Like Paul Brogan, he has a penmanship story.

"Writing," he muses, "was the most traumatic part of my day." He was copying letters when he heard a pointed rap on his desk. "I jumped ten feet in the air," he recalls. His first-grade teacher looked down at him and asked, "James Spain, what are you doing?"

What he was doing was writing with his left hand. "She took the pencil out of my left hand and put it in my right hand," Spain remembers.

That wasn't working, and when he got home, he told his father. The next day, Bill Spain drove young Jim to school in his state trooper car. "He pulled into the schoolyard, and this sea of kids parted," Spain recalls. His tall, blue-eyed, black-haired father strode into the school building in full uniform, Spain remembers, and came out again in less than ten minutes. "I never had to write right-handed again," Spain says.

Ken Jordan, also a leftie, remembers the slap across the knuckles, this time at St. John's. But it didn't take, and for some reason, his teacher left him alone. "I still write left-handed to this day," he says proudly.

St. Peter closed when Spain was in fifth grade, and he begged his father to let him go to Walker School and then Rundlett. Most of his friends in the White's Park area were Protestants, and he wanted to attend school with them instead of going to St. John's, now a regional school. "It was," he says, "a big debate at home."

His father finally agreed, on the condition that young James never miss mass. Spain attended Walker, Rundlett and, later, Concord High School.

Though he was eager to expand his horizons, Spain took mostly standard classes at Rundlett. He got into the wrestling program, and with kids he knew from the neighborhood, "I enjoyed the social aspect of junior high." At times it was overwhelming—"so many people"—but he found his place.

He had to walk or ride his bike to Rundlett: two miles a day to school, two miles home. "That was eighty miles a month," he said. His parents warned him not to cut through the state hospital grounds. "I was a Spain—that's all you had to say to me," he recalled. Spains accepted dares and don'ts. So of course, he cut through the hospital.

Karon Devoid liked her years at Dame School, where she made a fast friend, Emily Bartlett. "The other kids used to call us Salt and Pepper," she says. She remembers every one of her K–6 teachers' names.

In first grade, Devoid's desk was put in the hallway because "I talked too much." The administrative team wanted to separate her from her twin brother, Kirk, but they "fought tooth and nail" and remained in the same class. She found the schoolwork easier than Kirk did, but that never separated them, she says. She got good grades "after I learned not to talk so much."

Devoid was panic-stricken at the thought of going to junior high school but observes that the culture shock turned out to be "not that bad." She got to wear her first pair of nylons for Move-Up Day. By then, the family had also moved, off the Heights to a house next to her father's granite business on Little Pond Road.

Sandy Pinfield Miller attended Walker School through sixth grade. She loved Walker School and loved all her teachers, Miller says. She soaked up information and remembers the first word she ever read, "Look."

In fourth grade, the classes were split into groups and changed classes, spending their social studies, math, science and English blocks with different teachers, in preparation for Rundlett. Miller was in the A group and had an English teacher named Mrs. French. "She found we were so advanced in English, she had to give us different work. So she taught us to type." Annie Pinfield had an old Royal typewriter, and Miller remembers lugging the manual monster to school. "I think it weighed four hundred pounds, and

I weighed sixty pounds," she says. But she learned the new skill, and it served her well later in life.

Discipline was light and mostly effective, she recalls, with one boy acting up until the teacher moved his desk next to her own.

Miller eventually gathered a group of three friends to walk with to Rundlett and Concord High. Though their parents felt mostly safe about letting them walk, there were rules, she remembers. "When we walked to Rundlett, we had to go past the state hospital, and we were told not to walk through what was known as the 'bughouse.'" But they needed a shortcut, and they went through anyway, she added. They got to know some of the patients. "One man played the harmonica. Another one worked on the laundry truck, and he was cute," she says.

Music was more of a draw for Mike Philbrick than sports. He took up drums at an early age. He attended St. Peter's School through sixth grade. Though Bishop Brady was the school of choice for good Catholic families, his parents allowed him to go to Rundlett and then Concord High School because the Catholic school didn't have a band.

St. Peter's was strict, Philbrick recalls. "I was an altar boy, so that was a double whammy." The third layer of discipline came from his father, who was an officer with the Concord police. "He was a police officer, Irish and Catholic," Philbrick says, adding, "I didn't step out of line very often."

Though St. Peter's insisted on discipline for its students, that didn't bother Philbrick, nor did the dress code. "I can't complain, except that they didn't offer music and art," he says.

"School was structured," Jim Wentworth recalls. "You knew what to expect. Very few people got out of line." Standing in the hall was the worst punishment, and, he jokes, "That was really harsh."

But the actual worst punishment was when you got home, he adds, because parents invariably sided with the school.

And nobody played favorites, at least not at Rundlett Junior High School. Rundlett was "eye-opening" after the size and homogeneity of Dame, Jim Wentworth recalls. He was placed in a "division," a unit of children grouped by ability. That would probably not go over today.

One of his cousins was a teacher at Rundlett, but that didn't keep her from punishing Wentworth. "I was in homeroom with this kid Warren Wasson, and I was looking at my combination lock," he says. "He leaned over, and I good-naturedly shoved him away." The shoving match got Wentworth sent to Principal Carl Bartlett, he said, at his cousin's instigation.

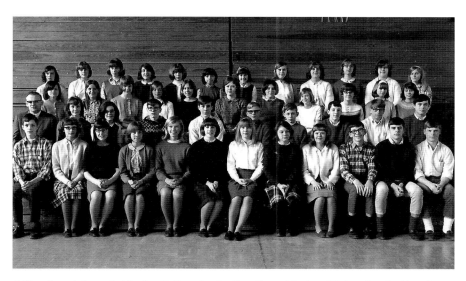

A Rundlett club, probably the *Quill* or the *Scroll* staff, scrubbed, coiffed and tucked in, circa 1965. In a few years, their own parents won't recognize these children, and they won't recognize themselves. *Alfred Perron.*

The faculty of Rundlett Junior High School poses for their official portrait in 1965. If only they knew what was coming…to education and to the world. *Alfred Perron.*

Wentworth played in the Rundlett band, though they didn't have uniforms. "We wore white shirts and white pants," he says. "We looked like chefs, or orderlies."

Allan Stearns played in the Concord High School band and remembers the group wanting to go to the 1965 world's fair in New York City. "It was huge," he says, "and we almost didn't go. We had to raise a lot of money."

But the CHS band of 1939, which had gone to *that* world's fair, got behind them, and the money was raised.

The band got to go and represented the State of New Hampshire, marching in the parade behind a Concord coach. "We were so proud," Stearns recalls.

Stearns was also part of the Rundlett band that played when astronaut Alan Shepard returned to his home state and was honored in a ceremony on the State House Plaza.[*]

And he was in band practice, at Concord High, when he heard about John F. Kennedy's assassination.[†]

Jim Rivers attended St. John's School, run by the "Sisters of No Mercy," through fifth grade. For the Catholic equivalent of junior high, grades six, seven and eight, he went to St. John's Hall, in a building on Pleasant Street. The Sisters didn't feed their charges, so Rivers and some friends often walked down to Star Hot Dog and picked up "two hot dogs and a root beer for fifty cents. For another ten cents, they would throw in fries."

Rivers briefly took piano lessons from a nun associated with Sacred Heart Church. "One day, I walked all the way to the church in the cold, and my fingers were half frozen. I couldn't hit the notes right, and she smacked me with a ruler. I was done."

By eighth grade, Rivers had had enough of parochial education. He transferred to Rundlett and segued to Concord High School. He found his profession in high school when he began filing sports stories to the legendary Ruel Colby, sports editor for the *Concord Monitor*. "I would cover a local game and then type it up and put it in the box outside the *Monitor* for Mr. Colby to pick up," Rivers says. "I got five dollars an article."

Fred Walker followed a different trajectory than Spain, Philbrick and Rivers. He went *into* parochial school after several years in the public system. Walker loved sports and played everything from Little League to Pop Warner. But as he grew older, he sensed favoritism among the coaches

[*] See chapter 8.
[†] See chapter 8.

and the governing boards of the teams. The preferential treatment seemed to point to the kids from the wealthier neighborhoods, and Walker worried that he wouldn't get a chance to shine, or even to play. "The handwriting," he said, "was on the wall." He went to St. John's Hall and, later, Brady and said, "That was the best decision I ever made."

Walker went to the old St. John's for his first two years of high school; Brady opened in his junior year. "I walked in the first day, and I was lost," he says.

Then he saw the gym.

Walker did get to play sports in Catholic school. In his first two years of high school, he practiced on the half court at St. John's Hall. The home games were played in the borrowed Concord High School gym.

"But now we had our own gym," he recalls. "It was mind-boggling. It was *ours*."

By the end of Brady, Walker had been part of three state championship teams: two baseball and one basketball. "At Concord High, I wouldn't even have been on the team," he says.

Catholic school wasn't as good a fit for Marc Boisvert. Since Sacred Heart School had no kindergarten, he turned five and went directly to first grade. He remembers such casual cruelty as a nun not allowing a young girl to go to the "basement," as we called it in those days, but calling her to the blackboard instead. The girl had an accident and burst into tears.

"It was," Boisvert recalls, "one of the most horrendous things I have seen a teacher do to a student."

But Boisvert was soon to see a deeper form of repression, when the "peace movement" began over Vietnam and his school suppressed free discussion.

Some of the elementary teachers were nice, he allows, and some were "magicians," able to slice two apples into enough to feed twenty-five hungry kids. "It was like the loaves and fishes," he muses. "Some of them were all right; some of them were—mentally ill."

He attended Sacred Heart through sixth grade, when the school closed its seventh- and eighth-grade classrooms. That meant going from a school of 90 students to one of 1,500, Rundlett Junior High, and "it was the biggest shock of my life," Boisvert says now. St. John's Hall was filled, and "my parents had to find a school for me," he remembers.

When the Boisverts went in summer to enroll young Marc, then-principal Samuel Richmond informed them that he was way behind his public school peers. The school practiced leveling, and Richmond said openly, "I'm not sure if I should put you in the fourth or fifth level." That was all the young teen needed. Boisvert says, at the time, it translated to, "I'm stupid."

He had begun to pull away from the Catholic faith—"I didn't believe everything I was taught"—but felt intimidated around non-Catholics, he says. Enrolling in Bishop Brady didn't help.

Boisvert found his release in music.* In the wake of Beatlemania, he and some pals formed a band, the Sun Chasers, and amassed a modest following. "We played at the Sacred Heart Church rummage sale, all day," he said. "We had groupies."

The group brought him up against the formidable Reverend Norman Limoges, the administrator for Bishop Brady. Limoges did not like "Louie Louie," a mostly incomprehensible classic by the Kingsmen. He told the boys, "Make sure you do not perform 'Louie Louie.'" "So we performed 'Louie Louie,'" Boisvert says with a shrug.

But Boisvert was to come up against Limoges, and other authority figures, in another fight that would challenge and affirm his core beliefs.†

Boisvert and Brady came to a mutual understanding, and he left. Boisvert went briefly to CHS and then to Dover High School. "I was," he recalls, "a mess." He tried Pembroke Academy and eventually came back to CHS, until his beliefs were challenged there.‡ The staff didn't like his growing interest in the peace movement. But one teacher, Tom Thurston, befriended Boisvert. "He refused to fail me," Boisvert recalls. Thurston assigned him an extra credit report on the then-new science of DNA. Boisvert was challenged and dug right in, and Thurston passed him.

Boisvert found his calling in medicine and became a registered nurse. He shared his skills teaching at hospitals and the New Hampshire Technical Institute. Ten years out from his GED, he found himself heading up a paramedic demonstration to a group of Concord High students. A grinning Thurston, now the principal, told him, "Marc, I knew you had it in you."

Though Omere Luneau's parents were nonconformists by fifties standards, and especially Concord fifties standards, they still placed him in Catholic school after kindergarten at Walker School. Luneau attended St. Peter's from first through eighth grade. "We were French Catholics," he says with a shrug, "and my father's wealthy sisters bought the bells for the church."

The younger Luneau questioned some of the beliefs the Sisters taught, and Catholic school wasn't a good fit. But his family persisted, enrolling him in a pre-seminary high school in Hamilton, Massachusetts. "I did not want to be a priest," Luneau says now. "But no one asked me."

* See chapter 8.
† See chapter 9.
‡ See chapter 9.

The seminary was even less of a fit for Luneau, and he ran away. The police found him sleeping under a bridge near Hampton Beach and brought him home. The Concord Police Boys Club and Officer Jimmy Ceriello worked with the youth, but he had to make his own choices and ended up in the Youth Development Center in Manchester. He learned to drink there, from a "counselor," and that activated his alcoholism. He was thirteen at the time.

Luneau was to attempt Catholic school once more, making it halfway through his sophomore year at Bishop Brady and "a couple of attempts at Concord High School, so I could beat the draft." A voracious reader, he educated himself, sitting in on friends' UNH classes and just about living at the Concord Public Library. "They saved me," he says of the library.

Christine Prentiss Gifford enjoyed her school years at Harriet P. Dame on the Heights, once she got through kindergarten. She had the formidable Miss Silsby for her half day, the same woman who had taught Gifford's mother. In elementary school, Gifford had blond hair to her waist, which she usually wore braided. "One day, some kid had scissors, and he cut off

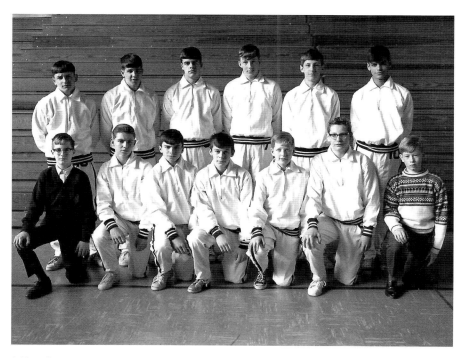

A Rundlett sports team circa 1965. *Alfred Perron.*

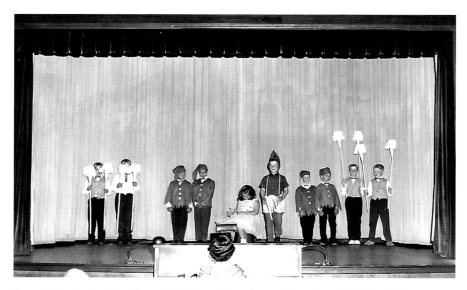

Dame School play. Alan Drew, Judy Bly, various elves and courtiers. What's with the Swiffers? *Alfred Perron.*

the end of my braid," she recalls. "Miss Silsby found it on the floor, and she thought I had done it."

The teacher informed Gifford's parents, banned the child from using scissors for two weeks and made her wear socks on her hands in the classroom.

"It wouldn't have been so bad if I had actually done it," Gifford muses.

She found comfort in the fact that her mother believed her story. But in those times, parents supported the teachers, so Winnie Prentiss didn't contest the punishment.

Dolores Robbins Flanders also remembers Miss Silsby, and not with longing. "She did put socks on your hands," she says, "and she was known to lock kids in a closet if they misbehaved."

Other than that, Christine Gifford enjoyed Dame School and didn't make any waves. "My sister Carol Prentiss Faretra got into trouble, not me," she says. But the little girl had a big conscience.

One day, she was summoned to the office of Principal Dorothy Guimond, a small woman who dressed in black and was even more formidable than Silsby. Gifford quaked all the way down the hall.

"I was scared to death," she says. "I couldn't imagine what I had done." Turned out Winnie Prentiss couldn't pick her daughter up after school.

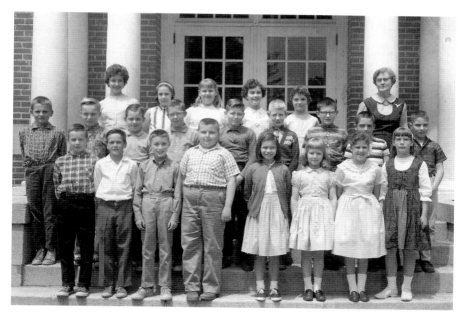

The combined fifth and sixth grades of the Millville School pose for a picture with their teachers in 1961. Millville was Concord's smallest elementary school. *Courtesy Jeanne Larosa.*

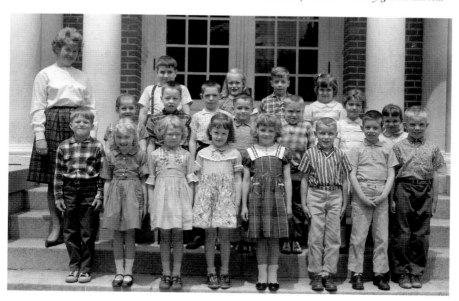

Millville's first grade class in '61–62. *Courtesy Jeanne Larosa.*

And what Ken Jordan remembers most is the sense of community. "I live in Florida now, and I'm still in contact with kids I went to kindergarten with," he says.

When planning a recent trip back to the Granite State, Jordan received texts from a couple of high school classmates. He arranged to meet them at Concord's Red Blazer on a certain date. "So-and-so invited so-and-so," he recalls.

The event snowballed, just like walking to school. Out of a graduating class of fifty-two people, thirty-four were still alive and seventeen of those showed up for the mini reunion.

"It was that easy," Jordan says, "to get half our surviving classmates."

Other Places

We never knew how lucky we were.

In 1954, a small Black girl stood at the center of a whirlwind, culminating in the Supreme Court decision to end segregation in public schools. It wasn't that easy. In 1957, nine Black high school students entered Little Rock High School to jeers, catcalls, projectiles and swearing. They were escorted in by federal troops. In 1962, a young Black man became the first of his race to enter a public university in Mississippi. He, too, was escorted by federal troops. We heard of it on the news, maybe saw a glimpse of it in *Life* magazine, but it didn't touch our lives. Not yet.*

Eventually, we left, bolstered with the diplomas the state or the diocese passed out to let us know we had, indeed, completed twelve years of education. The kids from the Hill went to private colleges; the rest of us got schlepped off to UNH and were fairly happy about it, because that was more than our parents had had. Others went straight to work or the military. Girls got married. Boys worked for their fathers.

We couldn't remember the state capitals, and only the ones who went into science remembered the periodic table. But we use the skills we learned daily and astonish our grandchildren every time we do math in our heads (not the author, thanks anyway) or write something in cursive. Because that was the way we were taught.

* See chapter 8.

Chapter 3

"DOWNSTREET" AND DOWN THE STREET

Forget Petula Clark, or at least assign her to some other community. When Concord kids wanted a break from the neighborhood, they didn't go "downtown," they went "downstreet." Paul Brogan writes in his excellent book, *The Concord Theatre*, "'I'm going downstreet' was the phrase you typically said when you went to Main Street or one of the surrounding streets to do some shopping."

In the fifties and sixties, Main Street was our mecca. Concord was an up-and-coming place, bristling with businesses. Some of the businesses were homegrown, like the Edward Fine clothing store and Ozzie Waite's outdoor shop. Some were chains, such as the four five-and-dimes, but local people managed and staffed them. The guy who sold you a lawnmower passed the plate at Sunday mass. The woman who sold you your spring coat (remember spring coats?) knew your mom from Eastern Star. The state capital was more Bedford Falls than metropolis.

Concord was a "company" town, with several large employers.

PAGE BELTING

Page Belting was one of the city's largest employers. Founded by Charles and George Page in 1868, it manufactured flat leather belting, necessary for all machine assembly during the Industrial Revolution. The company

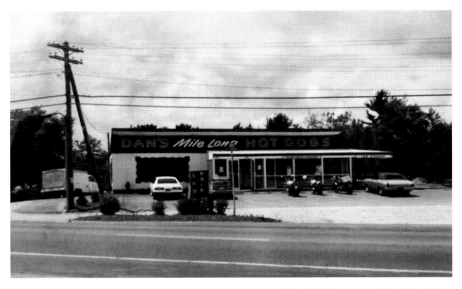

The Cusano family ran a fast-food restaurant on Loudon Road. The enterprising clan also sold ice cream at events such as band concerts and fireworks displays. *Cusano family.*

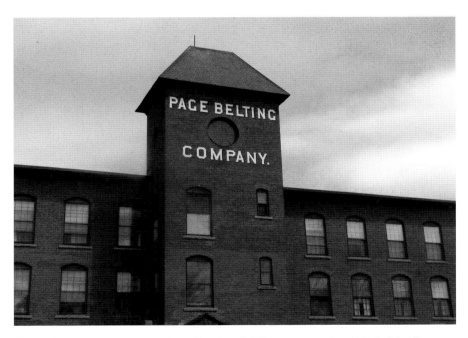

Concord was a company town, just with a lot of different companies. At its height, Page Belting was a major employer. The building has since been remodeled to house small businesses such as the Concord Dance Center. *Sheila Bailey.*

flourished during the nineteenth and early twentieth centuries, becoming one of the world's largest suppliers of power transmission belting. The four brick buildings between Horseshoe Pond and Route 202, including a four-story tower on the actual belt shop, were a Concord landmark for many years.

The growth and availability of electricity dampened the market for belting, but the Pages evolved to other leather products and in the 1950s began experimenting with synthetics, including polyurethane woven products and nylon core transmission belting. The company downsized to Chenell Drive in 1994 and then to Boscawen.

The original four-building complex on Commercial Drive is reconditioned and home to several small-and medium-sized businesses.

RUMFORD PRESS

The Rumford Press was one of the town's major employers for almost a century. Established in 1898, it employed up to one thousand people at peak and printed more than sixty national magazines, including *Reader's Digest*, the *Atlantic Monthly* and the *Humpty Dumpty* kids' magazine. But

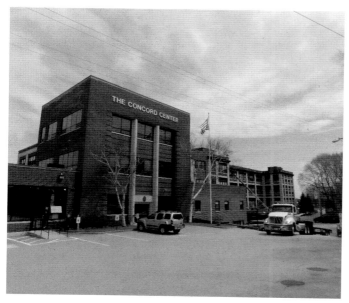

Page Belting, Rumford Press, the state and the quarries were major employers in the fifties and sixties. The Rumford Press building has found new life as the Concord Center. *Sheila Bailey.*

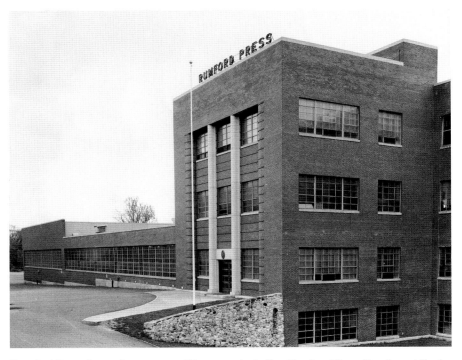

Rumford Press churned out reams of literature, including Readers Digest Condensed Books, while employing thousands of Concord men and women. *Concord Public Library archives.*

an economic downturn in 1983 led to its closing. It was down to four hundred employees. The last of these punched their last time cards on November 29, 1983.

SWENSON GRANITE

Many families, including the Swedes in West Concord, moved to the city to work in the quarries. The Swenson Granite Company was the biggest and is the sole survivor of the quarries, though at one time, a dozen quarries dotted Rattlesnake Hill. John Swenson, a Swedish immigrant, founded the quarry in 1883. The family-run quarry outlasted all the others, providing granite for the State House addition and annex, the Concord Public Library, several area banks and CBS headquarters on Sixth Avenue in New York City.

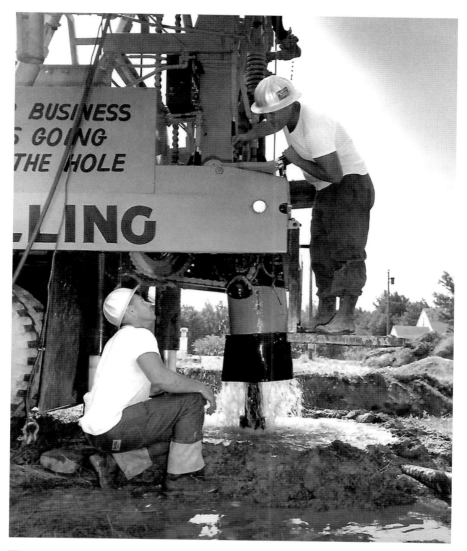

They were from Northwood, not Concord, but the Tasker family serviced homes and businesses in the larger town and were still operating at press time with their signature slogan, "Our business is going in the hole." It was, and it didn't. *Alfred Perron.*

In 2016, the company was sold to Polycor Inc. Swenson still owns and operates quarries in Woodbury, Vermont, and Barre, Vermont, as well as the original quarry in Concord. The company provides landscape and hardscape products across New England. In addition to the quarries, it operates retail outlets in Concord and Amherst, New Hampshire; Westbrook, Maine;

Newtown, Connecticut, and Rowley, Hanover, Shrewsbury and South Hadley, Massachusetts.

The original quarry was on Rattlesnake Hill, a tract of land five hundred feet above the Merrimack River, three miles in length and threaded with abandoned quarries. It proved to be irresistible to adventure-hungry Concord kids.[*]

We also patronized a few out-of-town businesses, such as Tasker's Well Co. That business was still going in the hole, last I checked.

The Corner Store

Concord in the fifties and early sixties was a city of neighborhoods and neighborhood identity. You went to your neighborhood school, swam at your neighborhood pool, walked to your corner store for a chilled Sunkist Orange. Rundlett Junior High School would eventually bring us together and bring us a wider world. But with limited public transportation and Dad taking the one car to work, neighborhood was what you had.

We lived on the Heights, and my mother and, later, I would walk to Frank's, Towle's, Longley's or Clark's. Jim Towle was a meat cutter, and my mother liked his products. Frank's or Longley's were good in a crayon or comic book emergency. But we really loved Clark's, despite the fact that you couldn't buy anything useful there, including edible food.

Ada Clark and her daughter Dorothy ran the store and lived out back. Dorothy, or "Dottie," was obese and could barely maneuver behind the counter. She was childlike, crying easily, but she also had the best gossip on the Heights, and my mother mined her knowledge, probably more than she should have. Ada must have been in her eighties when we knew her, but she was the brains of the outfit and also pumped the gas for customers. They sold candy, cigarettes and soda, bottles beaded with frost dug out of a red-and-silver metal cooler. We walked there barefoot on hot days, and the Sunkist Orange went down like water.

Because they lived out back, Ada and Dottie were available every day of the year, and I remember my father stopping by for gas one Christmas Day. Ada got up from her turkey to serve him, but he was a gentleman and always did his own pumping. He paid her, and they went back to their

[*] See chapter 6.

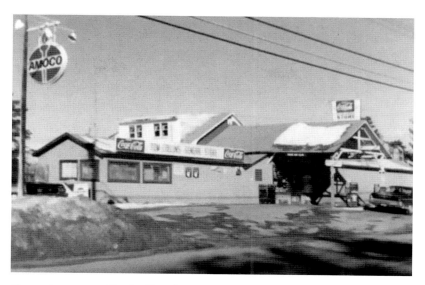

Convenience stores like the Tom Collins on Loudon Road were a boon for housewives who didn't drive or for their underage sons to pick up "the coldest beer in town." *Fred Walker.*

Concord was home to a small airport, serving mostly small private aircraft. In this photo, Mayor Davie (*center*) cuts the ribbon on an expansion of the main building to house the National Weather Service. *Alfred Perron.*

GROWING UP IN CONCORD, NEW HAMPSHIRE

meal. You could not see that today, even in a mom-and-pop. Or a mom-and-daughter.

The other mom-and-pop that endeared itself to this generation was the Tom Collins store on Loudon Road, which sold the coldest beer in town (on several peoples' authority) and wasn't shy about selling to underage boys.

North Enders patronized the Quality Cash Market or the Food Basket. Small, family-owned stores dotted the South End, and during his tenure there, Jim Rivers remembers Sullivan's Market on the corner of Bradley and Monroe, the Ideal Market, the Concord Street Market and the South Street Market.

A Deep Dive into Dives

Concord children roamed pretty freely, especially after we reached late elementary age, but there were places off-limits even to us. The state hospital comes to mind. And for much of our childhoods, the direst warnings centered on Carlen's Café, a dive on the corner of Main and Centre Streets across from Fortier's Pharmacy and Angelo's Restaurant, respectively.

Like other children, Paul Brogan was warned to stay away from Carlen's. "My father called it the 'flophouse.'" But in summer, with the car windows open, no one could avoid the "stench of bad beer," Brogan says. The stairs in the front were rotting away, as was the frame building. But, he adds, it was a landmark people used for giving directions. "It was our point of reference," he says, "but it was a horrible thing to see."

Sandy Pinfield Miller passed Carlen's on her walks from Lyndon Street—on the other side. "We were not allowed to walk in front of it. There were drunks on the steps," Miller remembers.

Paul Lillios has a different take. His grandfather owned a store next door to Carlen's, "the place for miscreants and mischief-makers," Lillios recalls with a chuckle. In addition to his own store, Lillios's father ran a home improvement company, and he often recruited his day labor from the men hanging around Carlen's. The younger Lillios would tag along.

"The first time I was allowed inside, I saw the shuttered door and I thought, 'This is a *real* bar—like in the movies.'" The smell of whiskey and sweat also alerted him to the fact that this was not a family restaurant with a couple of high stools for cocktail drinkers.

The Endicott Hotel on the corner of Pleasant and Main Streets was completed in 1894, the creation of the prominent Damon Brothers architects. It was the first major commercial building on South Main Street. In later years, the Endicott housed transients and indigents but was recently reinvented and now offers updated condos and apartments. *Alfred Perron.*

Lillios remembers a Skee-Ball game and Rumford Press workers congregating at Carlen's or the nearby Gaslighter Restaurant.

Carlen's fell to the wrecking ball, assuming there was enough left to wreck, in an early iteration of urban renewal. It was replaced by the Stewart Nelson Plaza. Nobody bothered to tell their children not to go near the Stewart Nelson.

We were also told to give the Endicott Hotel a clear berth. But since Main Street essentially ended at the corner with Pleasant, that wasn't all that hard.

Main Street

Corner stores, dives and Main Street, that garden of earthly delights. The main stretch of Main Street ran from the State House to the corner with Pleasant Street. It had hardware stores, shoe stores, the stationery store Brown and Saltmarsh. Remember stationery? It had independent clothing stores and an early iteration of Gibson's Book Store. And it had four five-and-dimes, the source for, well, everything else. J.J. Newberry's, Kresge's, briefly W.T. Grant and the stately red-and-gold flagship for the concept, F.W. Woolworth's.

We all loved the five-and-dimes. School supplies, inexpensive toys, Christmas decorations, comic books. Curtains, tablecloths and tools. Garden seeds and birthday cards. And the lunch counter, where you could sip a cherry Coke or go nuts with a pimento cheese sandwich or piece of pie.

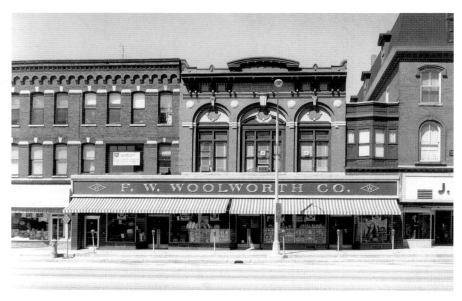

Woolworth's, with its red-and-gold facade, cheap make-up and doomed goldfish, was an anchor on Main Street in the fifties and sixties. *Ernie Gould, Concord Public Library archives.*

Like most of the chains', our Woolworth's had a slanted wooden floor. You could roll a marble from one end of the store to the other. I visited other Woolworth's around the state, and I think that was part of the corporation's blueprint for stores. Woolworth's also sold these amazing lampshades. They had scenes printed on them—a rolling ocean wave, a galloping horse—and when you lit the bulb, the images would move. The lampshades were in the back next to the goldfish that died on the way home.

Downtown also had Warren Street, a tiny, narrow street with old-fashioned shops including the Apple Tree Bookshop, one of two independent bookstores in the city; Granite State Candy, whose smell knocked one out; and French's, the hub for 45 and LP records.

Main Street was ours from the moment we got to Rundlett Junior High School. It was a short walk from the school through the South End to downtown, and we made it at least once a week, sometimes on the pretense of having to look something up at the library. We roamed Main Street and the side streets, not looking for anything in particular but relishing the freedom of being Out of the House and Out of the Neighborhood. Our fathers picked us up at the State House Plaza on the way home from work and asked the inevitable, "What did you do?" And we answered with the inevitable, "Nothing."

It was a different era, and Sandy Pinfield Miller remembers feeling safe most of the time. More importantly, her parents felt safe, and she was allowed to walk downtown, with her best friend, Lynn Vintinner, at a relatively young age. "I think we were eight or nine," she says, adding, "but we never went past the Capitol Theater."

They liked to visit Vintinner's grandfather, who lived downtown and had an ashtray full of quarters. "He'd ask us to pick up his dry cleaning then give us a quarter," she recalls. "He sent us to the post office, and we earned another quarter." On the way home, they would buy candy or soda at Merit Gas on Washington and Main, go in the ladies' room, sit on the floor and "solve all the world's problems," she says.

Because Miller's mother walked to work and back, her grocery shopping was more in the European mode. "She never did a week's worth of shopping at one time," Miller recalls. Annie Pinfield had a metal fold-up cart, and she'd shop every night on the way home, usually at the Food Basket on the corner of Washington and Lyndon. Sometimes Annie would stop at Abbott's Drug, also on Washington, for a cup of coffee before finishing her trek home.

Warren Street today offers Latin dining in the old police station and an expanded Granite State Candy. *Sheila Bailey.*

After Miller left home, Bill Pinfield began taking Annie to Shaw's in the new family car. "The cash register receipt listed everything they bought, and that was astonishing to her," according to Miller.

Miller and Vintinner also went to the Quality Cash Market for penny candy and, she says with a shudder, Tab.

They were allowed to walk downtown on Saturdays for the matinees, and they spent hours at the Capitol Theater. "We never went to the Concord Theatre," Miller says. "For some reason, our parents got the idea that they didn't show children's films." At the Cap, they saw Elvis movies, every one that came to town, and "a lot of Disney." Miller could get in as under twelve until after she turned fourteen, when the woman in the box office finally asked when she was born. "Busted," she says with a sigh.

Mike Philbrick and his friends also did downtown on Saturday afternoons. They had a ritual: first trying out the new goodies at Toy City, then wandering through Britts Department Store, then Weeks in the Capitol Shopping Center. "I got a vanilla frappe and a cheeseburger," he says. Or, depending on their whim, they'd go to Vegas on the corner of Bridge and Main. Sometimes they snacked at the Puritan, he said. They stopped at Haggett's sporting goods shop, first on North Main Street and then when it moved to South Main Street.

And though they walked everywhere, there was always a stop at Central Taxi, "so I could say hello to my aunt and uncle."

Woolworth's and J.J. Newberry's were also frequent destinations. "Newberry's floor smelled like a toilet," he says, adding, "but they had a good lunch counter."

Jim Spain also has vivid memories of downtown. "My maternal grandmother used to walk down with me; we'd go to Newberry's; she'd put me in the chair and order a hot dog and an orange soda," he recalls. He loved the five-and-dimes, especially Woolworth's and its wind-up toys. One time, he wound up a toy mouse, unaware of his grandmother's aversion. "She screamed and ran up and down Main Street," Spain recalls.

He remembers classics like the Puritan, the Youth Center, the Junior Deb, Diversi's and Garbo's Subs. Like many children of his era, he liked watching the change box go up and down the wire at JCPenney, the town's last stubborn holdout regarding cash registers.

Spain remembers Friday night, when the stores stayed open till nine o'clock, as a "big deal" in Concord culture. By fifth grade, he and his friends were walking downtown, going store to store, buying candy and "doing the stuff kids do."

Fred Walker and his pals did downtown on the cheap. "There wasn't anything I couldn't sneak into," he brags. The old Capitol Theater had the main entrance, for paying patrons, but Walker discovered a long walkway on the right that led to the exit door. Walker was an expert at paying for a ticket, then sneaking down to the exit door and letting in seven to ten guys who had been waiting on the walkway.

"The Concord Theatre was harder," he muses. "The alleyway was by the diner, and the light shone into the theater."

Ken Jordan remembers not only Saturdays in town but also the schedule he and his friends kept. "We'd get to 'upstreet' about ten thirty," he says. "There would be a gang of three or four of us. We'd go in the stores, then down to the railroad station, where we'd play in the lobby." The boys "climbed all over" the Concord coach, an antique even then. "One of us would pretend to drive the stagecoach; somebody else would pretend to shoot him," Jordan recalls, adding, "I can't believe we didn't destroy the coach." They finished in time for the noon matinee at the Capitol Theater.[*]

My family would drive to Main Street after our Friday night clams at Keniston's. (Did the Catholic meat ban mean anything if you really, really liked fish?) My father fed the parking meter (a nickel!). He and I did the shops we wanted to visit, then settled down to people watch and wait for my mother. She didn't get out much during the week, so Friday night was hers. She went to all four five-and-dimes, the clothing stores, the toy store and Granite State Candy. She went to the army surplus store even though we didn't hunt, fish or camp. She went to Hooz's Apparel, the go-to for formal wear, even if we didn't have a wedding or the like coming up.

She shopped until the shopkeepers turned out their lights and pulled down their shades.

You could buy anything from a ball gown to a ball-peen hammer on Main Street in the fifties. You had to. With only one car per family, trips to shopping meccas were limited and special. More often, you found it on Main Street: school shoes, school clothes, Christmas presents, wedding gowns. The shopkeepers could order something for you, and there was always the Sears catalog, but most of us found it on Main Street or not at all.

On Dad's day off, he and Mom would drive to one of the new chain groceries such as Champagne's. Though there was more to choose from there than at the corner store, the staff still mostly knew them by name.

* See chapter 8.

Top: Mayor Charles Davie (*center*) cuts the ribbon on a new Champagne's Supermarket in April 1962. *Alfred Perron.*

Bottom: Concord families made the short drive to Penacook to obtain deeply discounted items at the Giant Store. You never knew who you'd see or what you'd find. *Ruth Speed.*

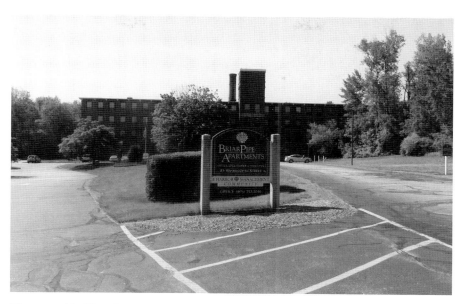

The venerable Giant Store, itself a remodeled factory, has been remodeled into the Briar Pipe Apartments. *Sheila Bailey.*

The Phenix Hall housed a number of businesses over its 127 years, including a small theater. Abraham Lincoln and Teddy Roosevelt spoke in its auditorium. *Alfred Perron.*

Dedicated shoppers also spent time at the Giant Store, a discount store in an old factory. The factory wasn't remodeled; the discount store just moved in on top of the factory leftovers, which lent it a kind of depressing ambience. The merch was remainders, leftovers and never-should-have-been-in-the-first-place. But there was a lot of it, and the dedicated shopper could find gems among the dirt. We were Heightsies, so we came in the scenic route, through East Concord.

The Capitol Shopping Center, with its Britts Department Store, gave us a taste of under-one-roof shopping. We still had Main Street, but we had another option. What really killed Main Street was the Kmart, with its mass-produced goods and streamlined shopping experience. And oh, those Blue Light Specials! Mom still couldn't drive, or not that much, but it was a twenty-minute jaunt from Concord to Hooksett on Dad's day off. Concord later got a King's, at the threshold to the Heights. The big department stores stayed open six nights a week, until Friday night downtown died an honorable death.

D'Amante's Field of Dreams

Armante D'Amante had a dream. The entrepreneur established the Twin State Lumber Company on the Heights in the early fifties. But D'Amante had bigger dreams, and as he looked at the broad plateau with its sandy soil, he saw not Burglar's Island, not the Plains, but a bustling retail community. D'Amante bought seventy-eight acres off Loudon Road, later adding fifty more, and named it D'Amante Place. He spent most of the sixties filling in the land and enduring wisecracks about when his mall would open. But D'Amante had the last laugh when he cut the ribbon on the Steeplegate Mall in 1990. Home Depot was to follow in 1992, and Shaw's, Target, Ocean State Job Lot and Michael's rounded out the offerings.

The mall had a good run as Concord's go-to place until the beginning of the twenty-first century. Acquired by Namdor Realty Group, it struggled to compete with big-box stores and discount chains such as Marshall's. In February 2022, the corporation ordered all "inside" stores to vacate. At press time, Steeplegate is awaiting its next use. And Main Street has come back.

I think of Main Street whenever I hear about developers creating "planned communities" where the residents can live, play and sometimes even work. The mixed-use development buildings frequently have shops

The *Concord Daily Monitor* produced an afternoon edition every weekday from this antique house on North State Street. *Alfred Perron.*

The *Monitor*'s forever home on Sewalls Falls Road. *Sheila Bailey.*

on the bottom floor, professional offices on the second and condos or apartments on the third, and the developer touts this as a "walkable community" and "the new Main Street."

But the original Main Street wasn't a planned community. It grew organically, as entrepreneurs and others saw a need to have everything in one place. An immigrant opened a bakery here, a World War I veteran opened a hardware store there. The five-and-dime offered one-stop shopping for people who had to walk to get what they wanted: a housewife with a stroller, a kid whose allowance was burning in his hand. Just as the general stores of an earlier era, Main Street was born out of necessity. And grew up around need.

And we've all lived to see it replaced, first by Kmart and Walmart, then by the malls, then by the big-box stores and, most tellingly, by the Internet. It has come around again through the "Buy Local" movement, and Concord's Main Street is enjoying a revival. It's not what we had, but it's better than it could be.*

* See chapter 8.

Chapter 4

IF IT'S TUESDAY,
THIS MUST BE KIWANIS

With the advent of the second half of the twentieth century, fresh off winning back Europe and settling with Korea, the returning GI Joes and their Janes experienced a burst of energy, which they channeled into joining. Concord bristled with clubs: Eagles, Moose, Kiwanis, Rotary, Fraternal Orders of this and that. The Zonta Club, the Quota Club, the Emblem Club, none of whose functions were clear to nonmembers but what the hay, you got to go out at night and say a password, maybe wear a sash or a funny hat. Real estate was cheap, membership was booming and many of the clubs had their own halls. Others set up chairs and took them down in places like the West Street Ward House. Women were among the joiners, as the advent of boxed cake mixes and really terrible TV dinners made their jobs at home marginally easier. There were Altar Guilds in the Catholic churches and Missionary Circles in the Protestant. And besides, with three Boston stations and Channel Nine, what else was there to do?

With the war not too far behind them, veterans' organizations and their auxiliaries flourished. Concord had a DAV, American Legion and VFW.

Some of Concord's clubs were homegrown. The Wonolancet Club owned its own facility, a sturdy stone building on the corner of Pleasant and South State Streets. Members of the Facebook "Concord Then and Now" remember it well. According to a Facebook comment by Rick Unger, the place had everything a man could want. On the first floor, there was a bar and pool tables, on the second level a kitchen and dance floor. Alwynne Fine notes on Facebook that the club was famous for its New Year's Eve

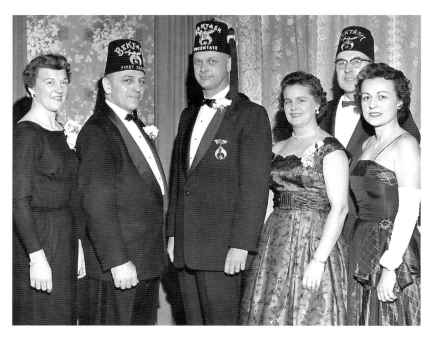

An installation at the Bektash Temple, the local wing of the Shriners. We loved installations; they gave us a chance to dress up. *Alfred Perron.*

The Rebekah Lodge holds its installation in 1962. *Alfred Perron.*

The Wonolancet Club poses for a portrait in 1961. *Alfred Perron.*

parties. But it was even more famous as a man cave, the place harried fifties husbands and fathers went to recharge. Jack Fraser sums it up on Facebook: "They were Concord's version of the Water Buffaloes."

Jim Wentworth's father belonged to Rotary. He was also an Elk, though not very active. Edna Wentworth belonged to the Emblem Club, the female arm of Elkdom, and she was extremely active, serving as their pianist for fifty years. "Don't ask me what they did," Jim Wentworth says.

Ken Bly's parents were joiners, and he remembers them being active in Odd Fellows and Rebekahs, two related lodges. "My mother was president of the New Hampshire Rebekahs, and one year she was on the national team," Bly recalls. "Dad was a chaplain with the Odd Fellows."

His parents were also involved in square dancing and bowling at Boutwell's, he adds.

Though his parents weren't members, Bly remembers a group called the East Concord Lamplighters, a community group aimed at fostering civic pride. They held an annual street fair down by the swimming pool and ballfields, he says. The Lamplighters sponsored a Little League team, a basketball program, dances for kids and socials for adults, all at the old firehouse.

Another installation, this of a woman's club. Possibly the Emblem Club. *Alfred Perron.*

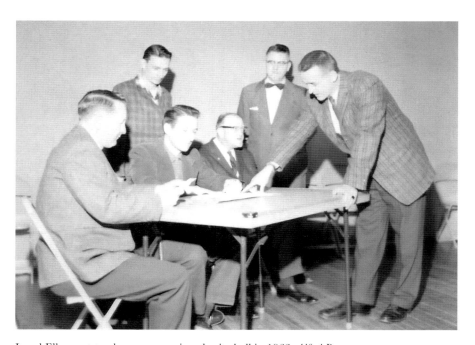

Local Elks meet to plan an upcoming charity ball in 1962. *Alfred Perron.*

Women of the East Concord Garden Club make a toast. To what, we may never know. *Alfred Perron.*

The Zonta Club poses for a portrait in 1962. Check out the person in the phone booth. *Alfred Perron.*

Above: Members of the 1961 boxing team at the Concord VFW. *Alfred Perron.*

Left: Many women's clubs held fashion shows. *Alfred Perron.*

Opposite, top: The whole cast of the fashion show. Wow, all that stuff could be worth something today. *Alfred Perron.*

Opposite, bottom: Preparing for the Bankers' Fashion Show, September 1962. These were probably secretaries or wives pressed into service. There were very few female bankers in '62. *Alfred Perron.*

Top: Even kids got into the act. Harold Estabrook (*right*) shows off his holiday outfit for the St. Peter's Guild Fashion Show in '62. *Alfred Perron.*

Bottom: Longtime members Annie and Bill Pinfield dressed as their favorite hobby for the Concord Camera Club's annual Halloween party. These days, they'd probably have to come as phones. *Alfred Perron.*

The Curtis family of Warner poses in their costumes for a Halloween party at the Concord Camera Club. We're not sure what a Native American has to do with an organ grinder, or what the boys are, but looks like they're having fun. Concord Camera's Halloween parties were legendary. *Alfred Perron.*

Above: Concord Camera Club member Harold Kimball channeled his inner convict for one of the club's Halloween parties. He worked at the prison, so it wasn't that much of a stretch. *Alfred Perron.*

Left: The perfect costume for these two stalwarts at the Concord Camera Club Halloween party. *Alfred Perron.*

All those Concord clubs gave rise to a subgenre, the fashion show. This event got the life choked out of it in the sixties, when we haughtily declared that "no one tells me how to dress" and then went out and dressed like every other hippie.

The Concord Camera Club was known for its Halloween parties.

Diversions

We kept busy. There were holidays to plan and execute, parades and celebrations, dedications and installations.

Fifties and sixties people had a seemingly endless flow of energy. When they were done joining clubs and schlepping their kids to Scouts and Little League, there was still the variety show. Nearly every organization put one on at some time or another. Concord outgrew the racist minstrel shows fairly quickly, to her credit, but there was still ample opportunity for middle-class people to make fools of themselves, if not of another race. The "variety" came from a spectrum of real talent to no talent, cringeworthy performances by your neighbor or friend's mom and some labored humor that usually involved men dressing up as women. There was a real pit band of hapless volunteers, including a local music teacher having at it with an untuned upright piano. The real talent shone against the non-talent, and it wasn't a bad way to spend an evening.

Concord residents could also see a first-run film in at least two venues: the Capitol and the Concord. The Capitol Theater was an architectural marvel, with a balcony, ample seating and side lighting in Art Deco sconces. The terraced front steps gave a grand effect, and the inside smelled of popcorn and, well, dust. Friends and I often walked from the Heights to the "Cap" and didn't think anything of it. Our parents didn't care, probably because our parents didn't know any better. If we got there on time for the Saturday matinee, we could snag balcony seats and throw popcorn, or whole boxes of it, down at kids we didn't like. Or, after fifth grade, at kids we liked. We saw cowboy shows and Disney features, preceded by cartoons and, in the early years, a black-and-white newsreel. It was a little dirty, a little dusty, and it had the faded grandeur of Gloria Swanson in *Sunset Boulevard*.

Jim Wentworth attended the requisite matinees at the Capitol Theater, being dropped off and picked up in his younger years. "When we got to sit

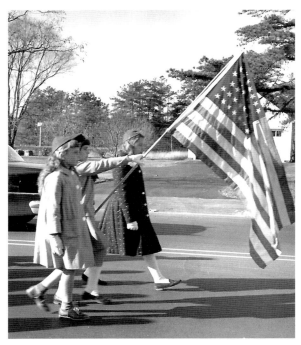

Left: With the Second World War still part of our parents' consciousness, patriotism was not optional. In a 1960s parade, marching Scouts included (*from left*) Linda Venne, Charlene Sorrenty and Kathleen Bailey. *Alfred Perron.*

Below: A local variety show, circa 1962, with Jim Stevenson as MC. We stopped doing minstrel shows fairly early on, but the concept of local talent was too strong to break. *Alfred Perron.*

Opposite: The Capitol Theater's Art Deco magnificence was saved by a community effort and now hosts homegrown and touring productions. *Sheila Bailey.*

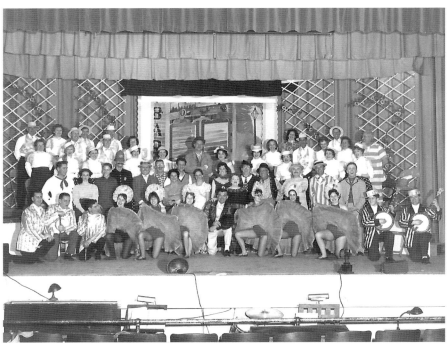

in the balcony, we felt like royalty," he says. "The movies themselves weren't memorable, however. *The Three Stooges in Outer Space*?"

Though he lived briefly across from the Capitol Theater, Marc Boisvert was late to the movies. A bout of childhood diseases forced him indoors. He remembers standing on a chair and watching his peers stream into the building for the Saturday matinee. A few years later, Boisvert was allowed to go, and he remembers being "mesmerized" by the art of film. He loved not just the movies but also the ambience. "The lights would grow dark, the heavy curtain would go up, the sound would come on and there was the movie. It was so dramatic!"

Boisvert relished the five-cent popcorn and ten-cent candy. "It was like heaven," he said. He also spent time at the Concord Theatre. He was friends with Peter Constant, Theresa Cantin's nephew, and hung out backstage with Constant.

The Concord Theatre, down the street from the Capitol, was smaller and more intimate. It was operated by two sisters, Theresa Cantin and Rena Constant, who seemed old when I knew them but probably weren't. The Concord had movie posters outside and in the lobby, treasured images of Vivien Leigh, Jimmy Stewart et al., none from later than the fifties. The

Left: The movie posters adorning the Concord Theater were just part of the experience in the forties, fifties and sixties but would be salivated over by a collector today. *Alfred Perron.*

Below: The Concord Theater was refurbished as the Bank of New Hampshire Stage and hosts concerts and smaller gatherings. It was a good save; Theresa Cantin would have approved. *Sheila Bailey.*

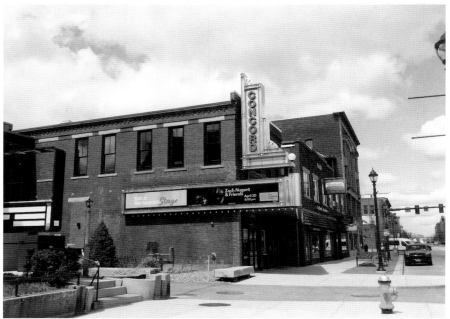

Concord had a warm family feeling; one night, one of the sisters' young sons or grandsons rode his tricycle down the center aisle. Theresa Cantin was a "mother" to the movie community, though she never married, and she was even known at one point to delay the opening of a film until a patron could get there. She refused to censor films but could be seen with her rosary beads when an especially edgy production was on-screen. For more information, see Paul Brogan's excellent book on the Concord and the city's movie history in general.[*]

Both venues were to be retooled, their tarnished glamour no match for the multiplexes with their clean restrooms, nachos and pizza. I don't think my mother would have allowed me to eat nachos or pizza from the Cap or the Concord, and she would probably have been right.

In a historic preservation move that was to launch a revolution, citizens formed a nonprofit group to save the Cap, reinventing it as the Capitol Center for the Arts and drawing local, regional and national acts. The board later raised funds to purchase the Concord Theatre, retooling it as the Bank of New Hampshire Stage, for music acts and smaller crowds. And the Red River Theatre moved in across the street, with indie, foreign and quirky films for the taking. With Gibson's Book Store and the League of Craftsmen now in the South End, the city had—wait for it—an arts district.

Channel Nine

Yes, our parents let us roam until suppertime, and we didn't have to check in on our cell phones, which didn't exist anyway. And yes, we spent time in the fields and woods, building forts and whatnot. But we also watched a lot of TV. That was our only "screen time," and we made the most of it with limited resources. In Concord in the fifties, that meant three Boston stations, an ABC, an NBC and a CBS; a clunky black-and-white public television station out of Durham; and Channel Nine.

On the Boston stations, we had Disney, on the weekday afternoons and Sunday nights; Ed Sullivan; and a comforting cocktail of homey sitcoms and classic Westerns. We had Boston news and Boston weather, but that was all right: we could look out the window and see if it was snowing. We had the programming available to other children across the country, and

[*] Paul Brogan, *The Concord Theater* (Concord, NH: Plaidswede Publishing, 2019).

we were the first generation to watch Saturday morning cartoons—if the rabbit ears were aligned.

Channel Nine was something else, especially before it affiliated with ABC. It did a lot of its own programming. Two stand out in our collective memories: *The Uncle Gus Show* and *The Clyde Joy Show*.

Uncle Gus was Gus Bernier, a war veteran who jumped into the new medium of television. He was famous among the PB&J set for his afternoon *Uncle Gus Show*, where he showed Popeye cartoons sponsored by such nutritional minefields as Jiffy Pop and Bonomo Turkish Taffy. He wore a polo shirt and a fishing hat, and kiddies came to Manchester in droves to an old Victorian house in the North End, the home of Channel Nine, to have their beaming faces on television. One of the rallying cries for my generation is, "Was you on *The Uncle Gus Show?*" Most of us were, at some point.

Gus Bernier was a true Renaissance man. At six o'clock, he changed out of his polo shirt and funny hat into a white shirt, tie and jacket to deliver the evening news, such as it was. Then he shucked the jacket to be the station's weatherman in his shirtsleeves, giving us all the local weather we were going to get. On went the jacket for the wrap-up of the day's news. It was a tour de force by a young man making the most of life in postwar America. Or something like that. Gus Bernier was many things but never the urban legend of the kiddie show pervert. He wouldn't have had the time.

Clyde Joy was a country singer who grew up in Manchester, not exactly the Nashville of the North, but he persevered and got gigs. Joy sang in the traditional country nasal style—we're not talking modern, "cool" country here—and he also yodeled. He assembled a band, including his wife, Willie May Joy, on the bass. His children, Bobby and Cindy, occasionally performed, too. The high point of our week was when Clyde sang his weekly gospel song. He took off his hat for this, and the harsh studio lights shined down on his bald head.

Clyde's principal sponsor was Freddy Goodnight of Hooksett, the mobile home king of the fifties, and Clyde created an advertising jingle to the tune of "Goodnight Irene." It went like this:

Freddy Goodnight, Freddy Goodnight,
For the very best buy on a mobile home, see Freddy Goodnight.

Thankfully, there were no further verses.

Clyde put out records, including one of his signature number, "Out Behind the Barn." He was a bit of an entrepreneur and bought up property

in Epsom for the Circle Nine Ranch, where he built a concert hall and held barn dances with country talent from across the Northeast.

Bernier and Joy became greater than the sum of their parts in the short-lived morning show *Coffee Time with Clyde and Gus*. They discussed the topics of the day by a wood-burning stove. Clyde sang at least one number. They had occasional guests. And the high point of each morning was when they opened and read their fan mail. It was like Regis and Kathie Lee with the fax machine.

Jim Wentworth did watch Uncle Gus, though he was never on it, and remains amused at how Bernier could go from Popeye cartoons to weather to hard news "and even Santa Claus," he says.

But he and his family drew the line at Clyde Joy. "That was *real* country music," he says, somewhat ambiguously.

The station eventually affiliated with ABC and got normal programming. But the Channel Nine memories remain in our collective unconscious.

Ken Jordan's family didn't have a television set until 1950, though the medium was available in Concord. One neighbor, a Mr. Stan Cole, managed a Coca-Cola plant and installed television antennas on the side. He rented space in the Jordans' barn. Mudgett Painters also stored its ladders with the Jordans. Cole eventually realized the impact TV was going to have, and he converted part of his home to a storefront. The neighborhood kids, especially the Jordans, would watch the children's shows play out in Cole's picture window: *Kukla, Fran and Ollie, Hopalong Cassidy, The Cisco Kid*. "We would sit on the sidewalk before supper and watch," Jordan recalls. "It was amazing—movies in a little box."

They also visited a friend of his sister's on Perley Street so they could watch shows such as *Howdy Doody*, he adds.

When Jordan's oldest sister was a junior in high school, she wanted to have friends over for what was called a "house party." "She was embarrassed that we did not have a television," Jordan recalls. By now, another neighbor was selling the appliances out of his home, and Jordan's dad went over and rented one just for the house party.

After that? Jordan chuckles. "We probably didn't let the rented one back out of the house." One argument the savvy Jordan kids used was, "Dad, if you let us keep it, we won't be on the street so much."

The family watched the new medium together. There were no separate screens in separate rooms, Jordan recalls. They migrated to the living room for Sid Caesar and his *Show of Shows*, Jackie Gleason and Ed Sullivan. Variety shows were huge, he says. "There was something for everyone."

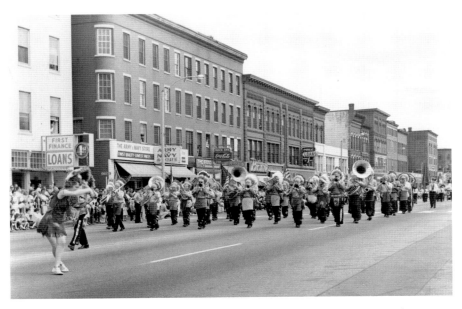

A local band performs on Memorial Day 1965. By now, they've probably changed mascots. *Concord Public Library archives.*

And his family talked about the shows. "They were history lessons," he says. "When we watched Red Skelton, my father would say, 'I remember when he came to the Palace Theatre in Manchester.'" Jordan remembers President Eisenhower announcing the end of the Korean War on the small screen and his parents taking the time to explain it to him.

NEVER SAY NEVERS

Concord also listened to, and in some cases played in, the storied Nevers Band. They are the house band for the annual Fourth of July celebration at Memorial Field, and when we were growing up, they visited all the city parks at least once during the summer. Our parents brought blankets and lawn chairs or sat in their cars. There were coolers full of food from home, or you could buy a Hoodsie from Dan Cusano's truck. We ran around with kids we knew, stopping only long enough to let our mothers slather us with insect repellent. When a number ended, the parents honked their car horns. The sun set before they were done, and it was thrilling to be outside at night,

with our friends, junk food and loud music. Glow sticks hadn't been invented yet, but the evenings had their own glow.

Paul T. Giles was conductor from 1960 to 1985 and remains the face of the band for boomers. His daughter Deborah Giles Lincoln is still involved with the band, serving on the board and playing the summer concerts.

"We used to say it was hard to tell where Dad stopped and Nevers started," Lincoln says.

Her family moved downstate from Woodsville in the early 1950s when her father accepted a position as a music teacher in Concord. George West, then the city tax collector, played French horn in Nevers Band and recruited Giles to play clarinet. Her mother, Priscilla Cushing Giles, and her brother Douglas eventually joined the band, and it was a family affair; Lincoln remembers the entire family sitting on the living room floor after a concert, filing Giles's used selections and bringing out the sheet music for the next concert.

Her parents were thrifty fifties folk, and when she wanted to learn an instrument, she remembers her father saying, "I have an extra flute and an extra clarinet. Which do you want?" "Today, parents would spend thousands," she says. They were thrifty in other ways. When Lincoln received her first Barbie doll and the accompanying clothes and accessories, she wanted a vinyl carrying case to stash Barbie's stuff. She ended up with a surplus clarinet case and hauled the doll around in that.

Though she came of age during the British invasion and at the tail end of the Elvis Era, Lincoln never rebelled against the marches and light classical pieces Nevers played. There was one exception: at the age of four, she became fascinated with a pop tune, "The Naughty Lady of Shady Lane." Paul Giles took time to wean his daughter from this piece of fluff, playing the entire score of "Peter and the Wolf" as enticement. But when the record was done, Lincoln recalls telling her father, "I still like 'Shady Lane' better."

Lincoln played with the band throughout high school, college and her adult life. It was in her blood, she muses. She likes the concert pieces because they're complex and challenging to a musician, and she enjoys the energy playing live gives the band and audience. She still remembers a concert at Mount Sunapee, when she was between high school and college and Nevers Band played in front of the base lodge. "There were thousands of people—the audience filled the lawn," she recalls. "It was amazing."

She's not the only Nevers legacy. Jiffi Rainie, daughter of Dr. Robert Rainie and granddaughter of Herbert Rainie, both band members, has been a conductor and board member. George West's son has played with the group. "We had four generations of Wests at one time," Lincoln says.

The band's full name is Nevers Second Regiment Band, and the name comes from its affiliation with the Second Regiment of the New Hampshire National Guard in the late nineteenth century. Claremont cornetist Arthur Nevers, its director for fifty years, provided the "Nevers" part. The band's pedigree also includes the Civil War Band of 1861 that accompanied the New Hampshire Regiment to Hilton Head, South Carolina. It is one of the oldest community bands both in New Hampshire and in the United States.

The band performs a repertoire of light classical, show tunes, pop and marches. It averages twenty concerts a summer, both close to home and at venues such as the Hampton Beach Sea Shell and the Saint-Gaudens Historic Site in Cornish. There are approximately forty members at a time, from all walks of life.

Allan Stearns played the trombone in bands at Rundlett Junior High School and Concord High School and at First Congregational Church worship services, but nothing gave him more of a thrill than qualifying for Nevers. "The last time I was in Concord," the central Florida resident says, "was to bury my mother at Blossom Hill. The Nevers Band was playing on the State House lawn, and I picked up a couple of chairs and went." Stearns talked with a couple of his former bandmates and introduced himself to others.

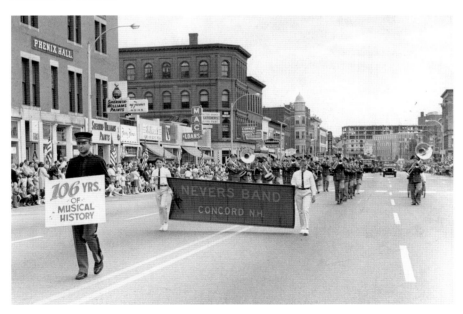

Concord loved a parade, and especially when her homegrown Nevers Band was playing. *Concord Public Library archives.*

A Nevers Band concert traditionally ends with "The Stars and Stripes Forever," and Stearns was tapped by his former bandmates to conduct the closing song.

"I never directed that band before," he says, adding, "It was one of my life's dreams."

The band plays on, at the Fourth of July shebang at Memorial Field, in the city parks and at other venues. And though her life has become complicated over the years, Debbie Giles Lincoln will most likely be there. "My husband, Earl, said, 'Do you think you should take some time off?' and I said, 'I'll see. I look forward to being with my band friends. They're like my summer family.'"

THE CONCORD COMMUNITY PLAYERS

The Community Players were founded in 1927, with a mission "to encourage, foster and promote the participation by amateurs in all phases of the theatrical arts." In the early years, the Players did all their shows at the Concord City Auditorium but also rehearsed and stored costumes and props

The Concord Community Players present one of their offerings at the City Auditorium, later to become the Audi. Looks like a drawing-room comedy. *Alfred Perron.*

there. A space crunch at the auditorium led to a thirty-seven-year search for their own place. Residents Elizabeth and Dennis Hager donated land to the Players in 1970, and they were able to construct A Player's Place, opening the doors in 1997. They present an annual children's show, a children's theater camp and playwrights' workshops and still produce three mainstage shows a year at the auditorium.

Walker Lectures

We also participated, and continue to participate, in a cultural phenomenon unique to Concord: the Walker Lectures. In 1892, Abigail Walker left $30,000 in her will to establish "a free course of lectures upon subjects of history, literature, art or science, and free dramatic, musical, literary, historical and other cultural events to be given in Concord." The Walker Lecture season runs from fall to spring and is a heady mix of travelogues, music and more. All shows are held at the Audi, are free and are first come, first served. The lectures weren't the only bequest from Abigail and husband, Timothy, but they're one of the most enduring.

The Audi

Concord's venerable City Auditorium opened its doors in 1904, on the west side of city hall. The town already had an opera house, and the building of the auditorium was challenged in court by Nathaniel White, who owned White's Opera House and worried about the competition. The city prevailed, and the auditorium was built. Good thing, too, because White's Opera House burned in the 1920s.

The auditorium continued through most of the twentieth century to host the also-venerable Concord Community Players (since 1927), the iconic Walker Lecture series, dance recitals, concerts and the ubiquitous variety shows.

But by the later twentieth century, the grande dame was showing her age. In 1991, a space-strapped city government threatened to convert the theater to office space. The community balked and created the Friends of the Concord City Auditorium, a 501(c)(3) nonprofit corporation, later morphing into the

The remodeled Audi (Concord City Auditorium) features stained-glass windows in its lobby. *Sheila Bailey.*

Concord's City Auditorium, or Audi, features this wall of tributes to volunteers who have gone before. *Sheila Bailey.*

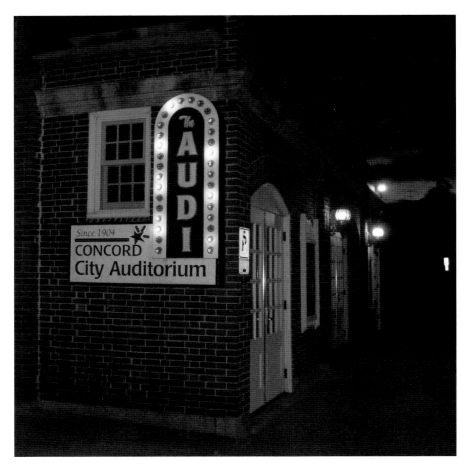

The Audi has been a city treasure since 1904. Formerly and formally known as the Concord City Auditorium, it was refurbished in the early twenty-first century. *Kathleen Bailey.*

cooler and cheekier Friends of the Audi. The Friends have since saved the structure and remodeled the lobby, and they volunteer their time ushering, baking and serving refreshments and cleaning up the house for three days in September, launching the season with a sparkling facility.

Like the Cap and the Concord theaters, it was a good save. Doesn't make up for the railroad station, but it was something.[*]

[*] See chapter 8.

Chapter 5

THE KIDS' TABLE

I n the middle of the twentieth century, Concord kids kept busy. We lived the storied Tom Sawyer life, wandering the woods, fishing and coming home with blueberry-stained teeth. We built the proverbial forts in summer and snow caverns in winter. But we also had a slate of activities available to us, and like our parents, most of us belonged to something.

SUMMER REC

Concord was honeycombed with neighborhood parks, and many kids took advantage of summer rec, most with the legendary Betty Abbott.

We glued Popsicle sticks into aliens or trivets, played games and participated in contests. I brought my fish to a Heights Park pet show and won "Quietest Pet." We took bus trips with Betty and built booths for the annual Peanut Carnival, an Abbott innovation that drew kids from the entire city. We did beauty pageants and talent shows. In a town where there was nothing to do, there was always something to do.

Though Sandy Pinfield Miller was limited to places she could walk to, the city itself was her babysitter and playmate. From the time she could go out on her own, she was in White's Park. She took swimming lessons in the summer and participated in craft classes with Betty Abbott. Miller enjoyed making her own jewelry. "I learned copper enameling, and I also

This earnest young Boy Scout troop was chartered out of St. Peter's Church in 1964. *Alfred Perron.*

made a wooden pin with alphabet pasta. It said my name, 'Sandy.' I still have it somewhere." She was in the pool twice a day, and she participated in Abbott's summer field trips to Benson's Wild Animal Farm and Bear Brook State Park. She skated on the pond in the winter.

Miller also joined Brownies in second grade and stayed in Scouts for eight years. And in fourth grade, she ventured outside the neighborhood to the Friendly Club, a long-gone Concord institution. Young working women could rent rooms in the large Victorian house next to the Concord Theatre. The program also had an educational component, and Miller's parents enrolled her in cooking classes, crafts and a baton-twirling class.

Concord also boasted the pools, one in each neighborhood, where we took Red Cross swimming lessons in the mornings and splashed around in the afternoons. It was nothing to walk over by ourselves—seriously, what could happen?—and swim twice a day. And most of our moms were blissfully unaware of the germs that lurked in public pools.

The bookmobile came to West Concord every two weeks, and Ginie Murphy was a frequent borrower. She also used the Penacook branch of the

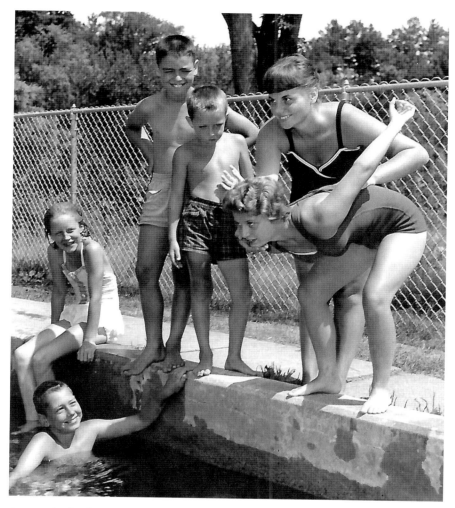

A network of swimming pools throughout the city, with Red Cross swimming lessons, offered kids a chance to get their feet wet and learn valuable skills. *Alfred Perron.*

Concord Library. She participated in the summer rec program at Garrison Park, doing crafts and taking bus trips to Hampton Beach.

But, she says, "I was mainly there to swim." Swim she did, biking five to ten miles to the pool and swimming for three to four hours. "But," she says, "it all had to stop when the ice-cream man came."

Jim Spain swam every day at White's Park, where his cousin Doug Spain was a lifeguard. "He used to give me twenty cents and say, 'Go get me a

SnoCone, and get one for yourself.'" Jim Spain played games on the tile-covered sun deck and participated in the arts and crafts programs.

He also learned how to hop the fence after the pool closed for the night. And he and his friends challenged themselves with a more dangerous pursuit: jumping off the cliffs in the Swenson Granite Quarry. "The higher the cliff, the more I felt like jumping off," he says. "I know every trail up Rattlesnake Hill."[*]

We had less structured summer fun, building forts in the woods, picking wild blueberries and walking to one of the corner stores for a Sunkist Orange or full-sugar Coke. We worked it off at the pool.

The city flooded areas in the parks to create skating rinks, and we glided across the ice on cold winter afternoons or played pick-up hockey. White's Park didn't have to flood anything—they already had the pond—and the skate house and piped-out music made for a total winter experience.

Before Doyen Park was paved to provide more parking for the courthouse, it was a city playground for kids in the North-Central area. Jim Peale remembers playing pick-up baseball in the park behind what was then the county courthouse. "We would hit foul balls off the courthouse, and Henry Daoust, the clerk of court, would come out and yell at us," he says.

"We did break a couple of windows," Paul Lillios recalls. "First floor, and some bouncers to the cellar level."

SCOUTING

Scouting was huge, and nearly every Concord kid tried Brownies or Cub Scouts. Some stayed in long enough to earn Eagle or Girl Scout Gold ranks. The discipline was an extension of school, with full uniforms and manners required. Darlene Plodzik joined Brownies for two weeks, then was never seen there again. When I asked her what happened, she said, "Oh, I mashed a cupcake in a kid's face."

Jim Spain came later to Scouting. The North End Cub Scout troop closed when St. Peter's School, its host, closed its doors. But Spain got in as a Boy Scout, with a troop chartered out of Immaculate Heart of Mary and with his father warning, "There are no quitters in the Spain family. I expect you to make Eagle Scout." Jim did, in December 1977. His son James III is also an Eagle Scout.

[*] See "The Quarry," page 106.

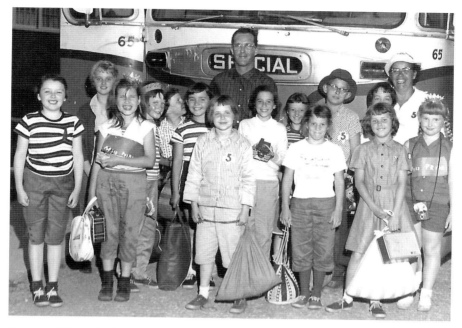

A group of Brownies heads home from the Girl Scout day camp at Bear Brook. Why are Linnea Beattie (*second from left*) and Christine Prentiss (*far right*) wearing crowns, and what's the deal with my shorts (*far left*)? *Alfred Perron.*

Jim Rivers was also a Boy Scout, attaining Eagle rank, in a troop run out of St. John's Church. The Scoutmasters were two ex-marines, "and we cleaned out the awards at Camp Carpenter." The troop had six boys achieve Eagle rank during Rivers's time there.

Jim Wentworth belonged to Troop 295, which met first at Immanuel Community Church and later at Immaculate Heart of Mary. The boys built a cabin. In the mountains? On a lake? In the deep woods of the North? No, Wentworth says. "It was on Route 106, across from the Perry Monument company."

Apparently, 106 in those days was isolated enough for a real camping experience. The boys stayed in the cabin in winter, and Wentworth remembers foraging for food in the remote wilderness of—the Heights.

OTHER CLUBS

4-H was big, mostly with farm kids. The Morrills in Penacook were always in the paper earning badges, patches and ribbons. The rest of us, like our parents, were joiners. The Y, then the YMCA, offered classes and programs, as did the Friendly Club on South Main Street.

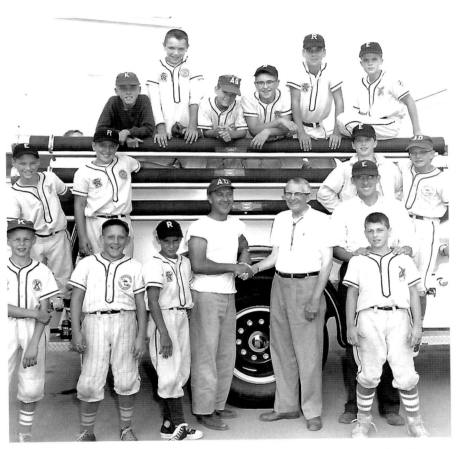

The state champion Little League team from Concord had its ceremonial ride in a fire truck after winning the championship in July 1960. It was the first state championship for the team, Concord American, and they defeated Rochester at a game in Somersworth. *Front row, from left*: Scott Taylor, Albie Edelstein, Ernie Coulombe, manager Frank Morono, Mayor Johnson, coach Dan Walker, George Kallechey; *center*: Richard Mills, Alan Bartlett, Don Milliken, Paul Durgin; *back row*: Jeff Smith, Dan Jameson, Larry Clark, Tom Enright, Richard Perron and Clayton Quimby. In addition to Somersworth, Concord defeated Concord National, Derry and Manchester. *Alfred Perron.*

Children could audition for kids' parts with the Community Players or put on a show in the barn. We played sports year-round (well, some of you did), and when we succeeded, the whole town turned out to fete us. Concord's Little League team won the state championship in 1960 and was duly celebrated. Another group of Concord boys won a state title in 1966 and were also duly honored.

"I felt like a celebrity," Jim Wentworth, their pitcher, says of that '66 championship season.

Summers were busy for a Concord kid. We were fortunate to live in a town that had resources: Girl Scout day camp, YMCA camp, the city's summer rec program. Here, some local kiddies learn the basics of carpentry at a Y summer camp. *Alfred Perron.*

THE FINER THINGS

Many of us "took" dance, although most of us weren't that good at it. My dance class offered tap, ballet, baton twirling and tumbling—in an hour, allotting fifteen minutes to each skill. I would have been better served "taking" a musical instrument. Many fifties and sixties kids did and huffed, puffed or banged their way down Main Street or Loudon Road for a series of parades. There were school orchestras and the inevitable pit bands for the inevitable variety shows. When Beatlemania struck, so did a flurry of new bands, as kids began to practice in garages and basements.

Karon Devoid didn't do a lot of extracurricular activities. "I didn't know there was such a thing as dance classes," she said. Her brother played hockey, and "my parents would drop us off at White's Park so he could practice." They walked home to Little Pond Road, in the winter. "It's a haul," Devoid says. "My parents never picked us up."

She did find an outlet in the Civil Air Patrol (CAP), a group recommended to her by a high school friend, Sue Lord. There were forty guys to a handful of girls—"All I needed to hear," according to Devoid.

Her parents were strict, and she couldn't join CAP unless she convinced her twin brother, Kirk, to join. "They had a double standard. He's a boy, you're a girl. If I wanted to do anything, I had to convince Kirk to do it with me."

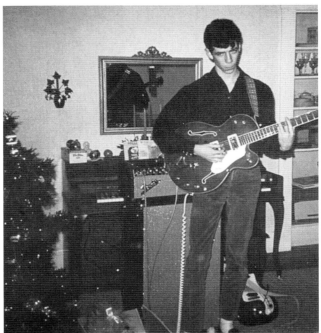

Left: We took out our frustrations, and discovered hidden talents, with the music explosion known as Beatlemania. Here, Marc Boisvert tries out his new Christmas guitar. *Marc Boisvert.*

Below: My colleague Paul Brogan notes that this play was a Girl Scout effort, an operetta titled *The Man with the Crooked Nose*. Brogan's mother, Clara, directed. The play was a fundraiser for a trip to Washington, D.C. Sons of the troop leaders were recruited to play elves, and Brogan is in the center front. *Alfred Perron.*

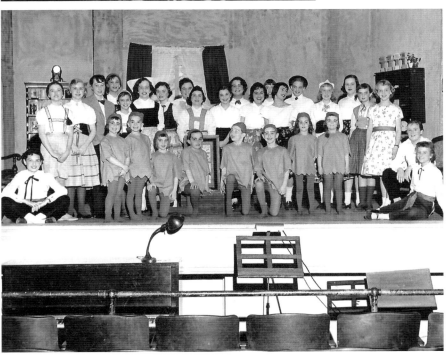

Many of the dance schools had their own competition troupes, and Evelyn Dyment's Dymenettes were no exception. Or maybe they're prepping for a giant Monopoly game... *Alfred Perron.*

Girl Scouts learn the art of babysitting with community volunteers. *Alfred Perron.*

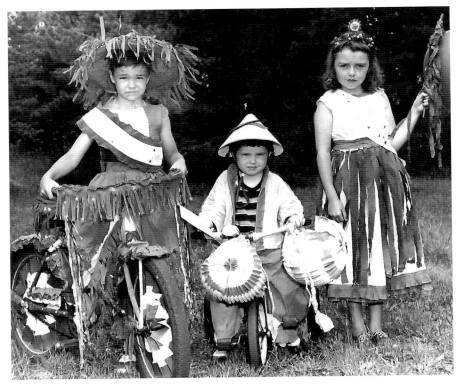

Above: Costume winners! *From left*: Pamela Madden, unknown child and the author. *Alfred Perron.*

Left: Local children in the costume parade at the Heights Fourth of July. *Alfred Perron.*

Members of a local Brownie troop stuff eggs for the rec egg hunt. *Alfred Perron.*

But she did, and once in, she "had a blast." "We did bivouac, we had uniforms, we learned marching and cadence." The chapter folded, and Devoid was "devastated," but it didn't end before she had a chance to travel to Montreal, Canada, with the color guard for Expo 67.

Devoid's childhood ended abruptly when she was sixteen and her mother had another baby, her sister Suzanne. In addition to starting dinner and doing laundry, caring for the infant fell to Devoid after her mother went back to work. "I raised her," she says, "for four and a half years." Devoid did have a car by now, and she could go anywhere she wanted as long as she took Suzanne with her.

"I got a lot of dirty looks," she says, "from women who thought I was her mother."

Unscheduled Time

Committed as we were, we also had the amorphous concept of "free time" and wasted our share of the golden hours of childhood. I never saw a dead hobo on a railroad track, but I had one harrowing afternoon the summer between fourth and fifth grade, wandering the woods with a little friend. An older boy had his father's shotgun, and he forced us to sit in an excavated area, an abandoned dirt hole. We sat for about two hours as he and another "big kid" stood guard. They didn't touch us, and after two hours he shrugged and said, "OK, you can go." So we went. I meandered home to the lunch my mother had prepared for me, a sandwich with the crusts cut off, carrot sticks and grapes, on a china plate with a cloth napkin. She asked what I had been doing, and I said, "Oh, nothing." This may be as close to a Stephen King story as I'll ever come.

The war was still with Concord kids of that generation. Our fathers had served in Europe or the Pacific; our older brothers may have gone to Korea. The ambience, especially with boys, was fed by John Wayne movies, Ken Jordan recalls *Guadalcanal*, *The Sands of Iwo Jima*, *Back to Bataan*. The boys in his crowd played war games interspersed with cowboys. A strip of undeveloped land on the banks of the Merrimack became their war zone. "This side was the 'Japs,' this side was the Americans," he says. "We dug foxholes and reenacted battles."

Real army and navy surplus was still available, and the boys fueled their war games with accessories from Mickey Finn's Army and Navy Store. "You could get a Springfield rifle for $2.98," Jordan remembers fondly. Not to worry; the barrel was fused shut. They snagged cartridge belts and helmets for pocket change or allowance money to make their battles more authentic.

Rick Tucker remembers playing baseball in the middle of Tremont Street and fishing for horn pout in the pond at the Blossom Hill Cemetery. He did a little hunting, noting, "You could walk around anywhere with a BB gun." He practiced with a bow and arrow and also experimented with model rockets.[*]

Ken Jordan remembers that his family enjoyed reading. His father worked at Rumford Press and would bring home "seconds" of the Readers Digest Condensed Books and the *Readers Digest* edition for kids. "We were always reading," he says.

[*] See "Every Boy Needs a Hobby," page 108.

We had simple pleasures and simpler pleasures. Karon Devoid grew up next to the Tom Collins store on Loudon Road. There wasn't much traffic on Loudon Road, especially in the winter, and the Devoid kids knew its quirks. "We used to sit out on the front porch in the winter, and there was a certain spot where the ice always pooled," she breezily recalls. "We'd sit there and watch people spin out."

Jim Wentworth liked sleeping out on the porch in summer, with a transistor radio tuned to the Red Sox games. "We used to have skipped signals, and I remember pulling in WPTR from Albany."

Wentworth and his pals also made snowballs and threw them from a vantage point on Heights Road down on unsuspecting cars on Loudon Road. Their luck ran out when they hit an unmarked cruiser.

The Heights was still largely undeveloped when Jim Rivers and his family got there. The massive state complex on Hazen Drive was yet to be built, as was Hazen Drive, so Rivers and his buddies roamed freely in the woods between East Side Drive and Loudon Road. They would ride out to the Soucook River off Route 106 and swim. Lifeguards? "No lifeguards," Rivers scoffs. There was another path to the river off Sheep Davis Road, and he remembers it had a rope swing. If any of the parents knew about this, they didn't say anything, he muses.

Ken Bly became a golf caddy at ten and ended up learning the game and competing at the country club next to the family farm. "I'd start playing golf in April, but on October 1, I was done," Bly recalls. "That was hunting season!" He hunted for two months, until the rivers and streams froze, and then it was time for ice fishing. "I took a package of hot dogs, my bait and my pole, and chopped a hole in the ice," he says. "I'd catch pickerel and bring them home."

And Fred Walker remembers his share of unsupervised fun. One time at White's Park, a boy named Harry Barlow shimmied up the pole of the basketball hoop and hung from the rim. But not for long. There was a crack, and the metal post broke off. "He jumped off at the end, otherwise he would have got crushed," Walker says.

If Concord was a safe place for children to play, it wasn't always safe for ducks, at least the ones in White's Park Pond. Walker has another story, about a boy who shall remain nameless. "OK, this kid picks up a rock and lets the rock go," Walker says. "It hits the duck in the head, and the duck's dead, OK? The kid gets his brother to run home and get a bag. They put the duck in a bag, and they don't know where to dump it."

Three days later, Walker recalls, an "awful smell" came from the White's Park pool. The pool was drained and the nearby sewer inspected.

"The kid had taken the top off the sewer and put the duck in it," Walker says gleefully.

THE QUARRY

Fred Walker was also on hand the day Johnny Georges jumped from a cliff at the quarries and almost didn't come up.

Concord had public pools in every neighborhood, within walking distance of nearly every home. But adventure called to the baby boomers, and nothing called more than the cliffs at the quarries. Maybe the parents knew about "Old Ballsy," maybe they didn't. But for kids who could get there, swimming in the pools created by blasting and jumping from the cliffs into said pools was about as much adventure as Concord was going to offer them.

It was mostly a guy thing, although girls were welcome to swim in the cold, clear water. But it was boys who leaped from the cliffs—"Old Ballsy," "Irving" and others. They hiked from Swenson's to Perry's to the New England Quarry. It was also a place for drinking, often cold beers procured from the friendly folks at Tom Collins on the Heights. Tom Collins didn't serve Tom Collinses, but it had budget beers and looked the other way when a teenage boy came in.

On a hot summer day, a boy named Johnny Georges had more than he needed, fell the one-hundred-foot drop from "Irving" at New England Quarry and almost drowned. Jimmy Mullaney was publicly credited with the rescue, giving mouth-to-mouth while another boy ran to the bottom of the hill and called Dr. Edward Penhale, the long-suffering pediatrician to generations of Concord kids.

Omere Luneau was there that day with pals Don McLane, Gary Chickering and Tom Wilson. Mullaney and Georges were part of an older group of boys, "and they were really, really drunk," Luneau recalls.

In Luneau's memory, Mullaney kept goading Georges to jump. Georges responded, "I'm no chicken!" Then, Luneau says, "He sank like a stone."

Luneau and McLane got to the water first, pulling Georges out. "He had blue lips, and he was choking," according to Luneau. "Mullaney started to give him mouth-to-mouth, and then Tom Wilson took over."

Businesses such as the Star Quarry lined the hills behind West Concord and gave city kids one more recreation spot, albeit unauthorized. *Sheila Bailey.*

The pond at the former Star Quarry is serene on an autumn afternoon. But its larger counterparts provided a means for daredevils of many generations to jump or fall from tall granite cliffs into the icy water. *Sheila Bailey.*

"They dragged him out and pumped him," Fred Walker recalls. "He came through, but it was very scary."

Walker was late to the scene and recalls looking at Georges and saying, "You don't look so good."

After the ambulance came, the boys piled into Mullaney's car and followed it. Luneau remembers a bumpy ride over the rough quarry trail and running a stop sign.

Mullaney took credit for the rescue and was featured in the *Concord Monitor*, though Luneau recalls it as more of a group effort.

Either way, it was a rough week for the Mullaney family: Mullaney's brother Steve fell down an elevator shaft while working on renovations to the Concord Savings Bank.

"We were a bunch of scared drunk guys," fellow jumper Ricky Mudge muses, adding, "We all survived and lived long lives—it's what we do."

Every Boy Needs a Hobby

Frank Perron had a scientific bent and an affinity for, well, blowing things up. He and buddy Jeff Gerade bought cases of dynamite and blasting caps from a local hardware store that shall remain nameless and probably isn't there anymore. The boys made rockets and pipe bombs, climbing to the tops of trees to set them off. "Nobody," Perron says laconically, "was hurt."

They set their sights on the Merrimack River, throwing individual sticks of dynamite into the water. It wasn't the worst thing in the Merrimack in the 1950s, but it didn't help.

The boys' interest in blowing things up reached a crescendo with their plot to blast holes in the Swenson Granite cliffs and flood the city of Concord.

By then Perron owned a car, an Austin-Healy, and he remembers driving up the bumpy trails of Rattlesnake Hill, with Gerade holding the dynamite in his lap and giving "riding shotgun" a new connotation. "After they abandoned a pit, it would fill up with water," Perron explains.

"We thought we would blast the side of the rock, and the water would pour down over the city." They set their charges, backed off and waited for the explosion.

"All we saw," he says now, "were bubbles coming up."

Rick Tucker also enjoyed blowing things up. He and his sister usually had a booth at the Peanut Carnival. Their offerings initially were things like ring toss and shave the balloon. But Tucker was always reaching for more.

"One year we took Coke cans and taped them together, with a tennis ball in the middle." Tucker's voice, at sixty-three, still holds glee at his creation. "We put on some lighter fluid, lit it, and it took off like a cannon. Other kids would try to catch it." Today's Kid Police would probably have had him at "lighter fluid."

SAFE AT HOME

No matter their neighborhood, Concord kids felt a freedom to roam. With a "try doing that today" awe, Heights kid Jim Wentworth remembers riding his bike not around but through the National Guard Armory site on the corner of Loudon and Airport Roads. Nobody ever said he couldn't. He also rode his bike through the Concord Airport and stopped to get candy from the machine in the lobby. Nobody ever told him he couldn't.

Nobody ever told Wentworth and his buddies that they couldn't *walk* over I-93's overpass on their way to the Saturday matinee. "We went up and over," he says, adding, "But we didn't tempt our luck on the way home."

Fifties and sixties kids weren't coddled and didn't coddle themselves. Wentworth remembers one day in February 1967, when he was home sick from school. He had a cold aggravated by his asthma. His mother went to Fortier's Pharmacy to get him a new inhaler. "She made sure I was comfortable, then went about her day," Wentworth recalls. "But I managed to break the inhaler and had an asthma attack." He didn't want to get in trouble, so he got dressed, walked downtown, bought himself a new inhaler and slipped back to bed.

When he was eleven or twelve, Jim Rivers stole a package of baseball cards from Sullivan's Market. His companion snitched on him, and in a scene straight out of *Leave It to Beaver*, he says, "My mother marched me right down to Sullivan's, and I returned them." Rivers later became friendly with the owner, Herbie Sullivan. When Rivers grew up and was working for Governor Steve Merrill, he remembers accompanying Merrill to an event where Sullivan said to the governor, "I don't care who *you* are. Where's Jim?"

Like Frank Perron and Rick Tucker, Ken Bly was no stranger to things that went *boom*, in the night or in the daytime. He shot off a firecracker on

Above: The Children's Ward at Concord Hospital. Why are fifties nurses always so creepy? *Alfred Perron.*

Left: Tom Rollins (*right*) receives the Safety Award at Rumford School. *Alfred Perron.*

the bus going home from Rundlett and for his transgression was barred from the bus a week before school got out for summer. The banning didn't faze Bly. "I rode my bike to Rundlett for that last week," he says. "From East Concord." He can still remember the route: up Portsmouth Street, across the highway, past Horseshoe Pond, down Main Street to the South End.

"I made better time than the school bus," Bly says.

Royal Ford didn't have to go far to learn risk-taking: his father, Lorne Ford, raced cars and motorcycles. The younger Ford remembers being hooked into a parachute behind his father's Harley-Davidson; with a rope tied to the motorcycle, Lorne would pull his kids across a potato field, in the air, dangling from the chute. "Nobody," Ford says, "ever got hurt."

On winter afternoons, Ford and his friends would grab the back bumper of the mail truck on their way home from Dame School and slide along the frozen ground behind it. Nobody told them they couldn't.

Starry, Starry Night

We enjoyed formal events such as the Peanut Carnival and the Kiwanis Trade Fair, held first at the Highway Hotel before we got the Everett Arena. Kiwanis weekend was kid heaven, especially if you were old enough to bid the folks goodbye at the gate and wander the grounds with pals. We browsed the commercial booths in the arena proper, scooping up pens and pencils and measuring spoons and yardsticks, local swag we even used sometimes. We ate our share of cotton candy, roasted peanuts and curly fries, all of which settled in our young stomachs like lead or didn't, causing embarrassment when we threw up on one of the rides.

When we were older, we got to go at night, sans parents. We ate more junk and stood in line for carnival rides. The rough-looking carnie would strap two or three of us into the Ferris wheel, with a satisfying clank, and we'd go up a little bit at a time while other kids were loaded on, one clank of the wheel at a time. Finally, we were in motion, and we soared above Concord, looking down at the color and bustle of the fair, looking across the river to a town where the lights were dimmed and the buildings barely stood out, looking beyond the town to darkened forests and fields we had yet to explore. It was our world, and we owned it, at least for one night.

ALL TOGETHER NOW:
THE BICENTENNIAL

Concord's bicentennial in 1965 marked one of the last times the whole community got together for some innocent, small town–style fun. Vietnam was already here. Trade winds would take away the comfortable center of "downstreet," sending shoppers hither and yon and gutting Main Street until, like a cosmic puzzle, it reassembled itself. By the time four years had passed, children would be questioning parents, parents would be questioning children and some parents would be questioning the government they'd fought for. But first, we had to celebrate where we'd been.

The city council hired Dudley and Marilyn Remus of Texas to direct the bicentennial celebration. It went on for a year, culminating in an "amazing parade" (Paul Brogan) and a seven-day pageant. Time capsules, queen contests and the famed wooden nickels marked a year of celebration.

J. Richard Jackman was the president of the bicentennial organization, and Charles Davie, a town official straight out of central casting, was the mayor. Nobody cut a ribbon like Mayor Davie, and nobody presided over a celebration like he did. With the Remuses at the helm, it was a year like no other.

Women of the community formed Bicentennial Belles chapters. Men grew beards and joined Brothers of the Brush chapters. The chapters competed in various events, including weekly tug-of-war competitions. Joe Andrews III was in the Mountain Men. "We won the mud pull in front of the Highway Hotel," Andrews recalls. "We defeated the plumbing company, which had a guy they would bring to the pulls in a cage."

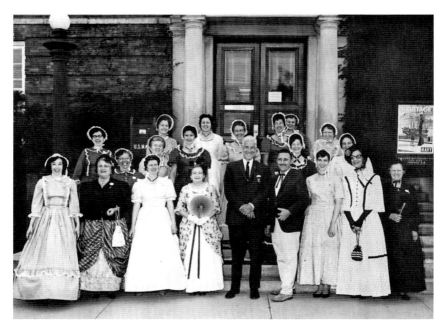

Townspeople jumped into the bicentennial with both feet. Men joined chapters of the Brothers of the Brush and grew beards. Women joined chapters of the Bicentennial Belles. A group of city hall workers is seen here with Mayor Charles Davie. *Alfred Perron.*

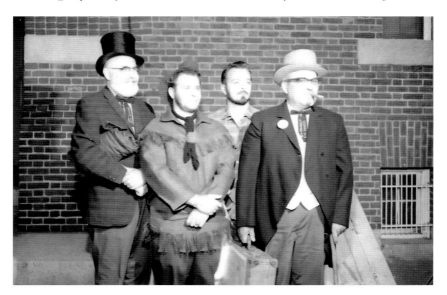

Some Brothers of the Brush show off their beards. *Alfred Perron.*

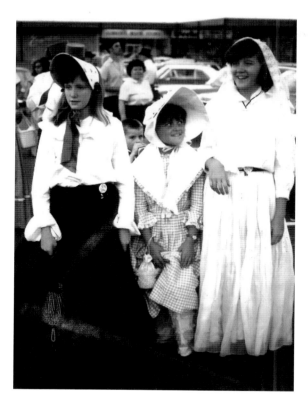

From left: Sandy Pinfield Miller, Joanie Vintinner and Lynn Vintinner show off their period finery at a bicentennial event. *Sandy Pinfield Miller.*

Dick Cimikowski also remembers the tugs-of-war. "Someone tied their end to a car and dragged the other side through the mud," he recalls.

There were souvenirs galore, from Stephen Winship's history of the town, *At the Bend in the River*, to a twenty-four-page booklet to ceramic buttons and the famous souvenir wooden nickels.

Special groups formed for the bicentennial, such as the Belles and the Brothers, while established clubs and organizations gave a historic flair to whatever they were already doing.

And the year of events culminated in one breathtaking week, August 14–21, 1965. August 14 was Government Day; August 15, Religious Heritage Day; August 16, Historic Appreciation Day; August 17, Business and Industry Day; August 18, Youth Day; August 19, Ladies' Day; August 20, Homecoming Day; and August 21, Coachmen Day. There were seven performances of the pageant, with pre-performance entertainment. Ladies' Day included a free coffee for "white collar girls" at nine thirty in the morning at city hall. For women who didn't work outside the home, the

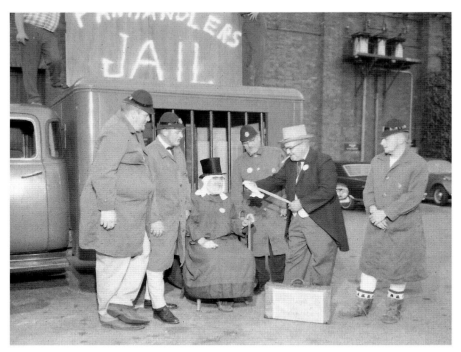

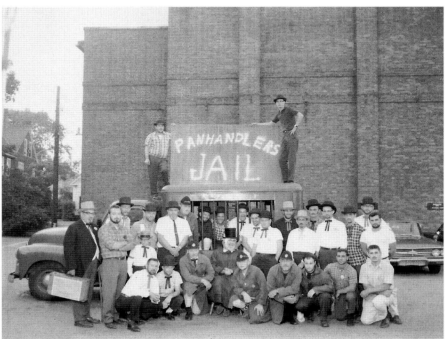

Opposite, top: So-called Kangaroo Courts called out errant citizens. *Alfred Perron.*

Opposite, bottom: Law and justice at a Kangaroo Court. *Alfred Perron.*

Above: The coach that opened the West, in the city's gala bicentennial parade. *Alfred Perron.*

day offered the inevitable fashion show and a tea at the New Hampshire Highway Hotel.

The top prize for the Bicentennial Queen was a trip to Bermuda, and in those pre-Orlando years, going anywhere was a huge deal. Thirty young women vied for the title. They were also eligible for a raft of prizes including clothing, jewelry, a picnic basket, a transistor radio and a Teflon fry pan.

The Bicentennial Pageant ran for seven days, and thousands of people trampled the grass in Memorial Field to see the town's history on stage. Each performance was bracketed by something called "Pre-Pageant Entertainment" and fireworks.

Ginie Murphy had to ride the bus home from school and was unable to participate in extracurricular activities. All that changed the summer of the bicentennial, when she was tapped to be an "Indian princess" in the pageant. The princesses wore gold lamé dresses, a fact that has never been

CONCORD,
N. H.

BICENTENNIAL
AUGUST 14 - 21, 1965
Souvenir Book

Above: The Nevers Band honored its home community by marching in the bicentennial parade. *Concord Public Library archives.*

Left: The Souvenir Book told us everything we needed to know. *Kathleen Bailey.*

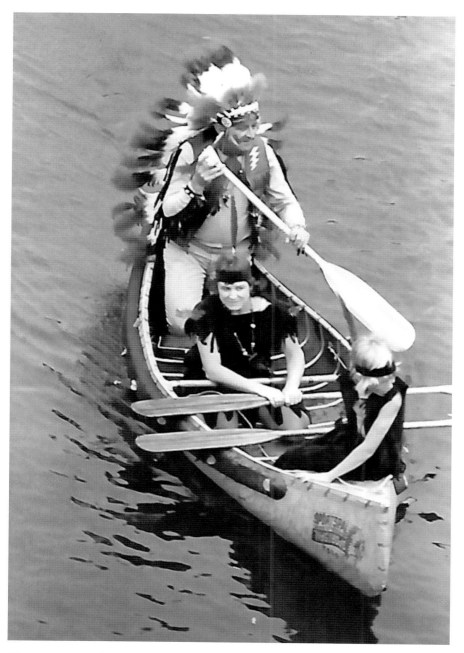

"Native Americans" approaching the Bend in the River, Concord's earliest designation, by canoe. Part of the official celebration of Concord's bicentennial in 1965. We wouldn't do it like this today, but you don't know what you don't know. *Alfred Perron.*

Left: The author's uncle Almore Perron gamely volunteered to be one of several Abraham Lincolns. *Alfred Perron.*

Right: Some prankster bestowed Abraham Lincoln's hat on the State House Plaza statue of Franklin Pierce. It's a stretch, but... *Alfred Perron.*

explained, and they danced onstage. Murphy remembers slipping in the dew on the wooden steps and falling down. The princesses were drilled in their routines by the Demers Dance Studio, and Murphy remembers performing in the pageant as "one of the most fun things I did as a kid."

The episodes included a prologue, "Land of the Redman," "Advance of the White Man," "Birth of a State," "Let Freedom Ring," "From Town to City," "The Light from Above (Mary Baker Eddy)," "On to Fame (the Concord coach), "Dawn of Education," "The Iron Horse," "The Power of the Presses," "A House Divided," "Steeeerike Three," which had baseball and can-can dancers, "Turbulent Teens," "The Decade of Fabulous Nonsense," "For One Cause—Freedom," "The Atomic Age," "Do You Remember?," "To the Future" and "Wheel of Progress." There were Civil War soldiers, Keystone Kops, Indians, bootleggers, Concord coaches, King Charles I and three different Abe Lincolns. There was a tribute to Beatlemania with a character described as "Teenage girl—er, boy?" and a salute to the late John F. Kennedy. If it fit, it went in.

The town buried a time capsule, including a wood fragment from the 1910 State House dome and a marble fragment from the 1959 Boston and Maine Railroad waiting room. There were bumper stickers, souvenir books and the wooden nickels. At the committee's invitation, clubs, churches and private citizens submitted material for the capsule. Some handwrote their entries, some pecked them out on manual or early electric typewriters and some submitted brochures about who they were and what they did. The sentiments expressed were endearing and sometimes appalling, with one church helpfully listing the men of the congregation but none of the women. The letter from the Unitarian Church noted that one Ralph Waldo Emerson was a guest preacher before the church obtained a permanent pastor. The Business and Professional Women made special note of their bowling team, which was seventy-five years old at the time of the celebration. And in the City Departments section, Robert Ayer, who followed Betty Abbott in the Parks and Rec position, noted that "during

Left: Jim Milliken reads the bicentennial proclamation as Boy Scout Paul Nyhan stands in attendance. *Alfred Perron.*

Right: Boy Scout Paul Nyhan rings the reproduction of the Liberty Bell in Concord's bicentennial celebration. *Alfred Perron.*

the summer of 1965 we used the greatest amount of chemicals for the sanitation of our pools. We used 5,700 gallons of chlorine and 2½ tons of diatomaceous earth." Good to know.

A Time Capsule Committee was organized under the direction of Rebecca Lougee, an official with the Merrimack County Savings Bank, and the capsule was opened on June 7, 2015, in the presence of Mayor Jim Bouley; Jim Milliken, chairman of the Concord Historical Society; and Brent Todd, chair of the 250th Celebration Committee. The capsule was on display at Merrimack County Savings Bank until November 7, 2015, and is scheduled to be reopened in 2065.

The gang was all there, at least for one summer, before the world we knew shattered like a mirror. We would come back together for other reasons, but they would be sobering reasons. The space shuttle death of a beloved schoolteacher. The bombings of the World Trade Center and Pentagon. School shootings, mercifully not here, but what is "close" and what is "far away"? We came together to mourn and protect each other.

By then, we knew what community was.

DOWNTOWN, DIVERSITY AND OUTER SPACE

I t was an old redbrick city, dingy at best, dirty at worst. The ghosts of ancient advertising hung on the buildings, even as the sixties stormed in. We built over old facades or ran enterprises out of tiny ones, such as the Junior Deb, which couldn't hold more than two people at a time—and woe to us if one of the people was a "chubbette," or what we called plus-size in that era.

There were town characters, regional characters and national characters who made us proud.

FRANKY TRANSISTOR

A young developmentally disabled man roamed the streets of downtown with a transistor radio pressed to his ear. He even marched in parades with his radio, and he earned the nickname Franky Transistor. People pretty much left him alone, which is amazing in the pre-diversity era and the years when bullying went unchecked. But Franky was ours, and with the state hospital at full strength, we saw stranger sights.

The town took care of Franky Transistor. Paul Brogan recalls that when he was working at the Concord Theatre, Frank would wander in, stand at the end of the auditorium and check out what was playing. Owner Theresa

Cantin let him hang as long as he wanted to, although she gently asked him to turn the radio down so he wouldn't disturb the paying patrons.[*]

Betty Abbott

Betty Abbott could have been anything, and before Concord, she *was* somebody, an actress and composer with a respectable career on the stage, including one song she cowrote, "What In the World," that made it into the country's top ten. She was friends with the likes of Doris Day, who later visited her in Concord. The apocryphal story has it that Betty was on her way to Maine, the train stopped in Concord, she learned we were hiring a rec director and she simply stayed.

She revolutionized rec, bringing in the Peanut Carnival, the Ski and Skate Sale and other programs. She didn't delegate much but was always out there with "her" kids, leading bus tours, gluing popsicle sticks or whatever the day's project was. She gave of her free time to appear in Community Players shows, including a *Mame* and a *Carnival!* directed by Paul Brogan's mother, Clara.

She was "out there" in another sense few of us understood at the time, living openly with her partner, Dr. Grace Pennington Surber. Gay and lesbian life in the fifties was furtive and glossed over, with women calling each other their "roommates" when the relationship ran much deeper. Betty and "Penny" didn't pretend. They were who they were, and our parents reluctantly accepted them.

At my young age, I didn't understand the true nature of the Abbott/Surber relationship, but I knew Betty wasn't like my mom and her friends. One of my pals and I signed up for her bus trip to Hampton Beach. We were waiting to board the bus, and the driver was late. Betty said something like, "Where the hell is that driver?" and we reared back because our moms didn't swear. Period. None of the moms did, and few of the dads, at least in front of us. But Betty was Betty—if not larger than life, a big enough personality to put Concord in its place.

Paul Brogan is gay and came out to his family early, at Thanksgiving in 1960. "My father was holding the knife," he says. "He just looked at me." But the senior Brogans were accustomed to the undercurrent of gay and

[*] Paul Brogan, in conversation, 2022.

Betty Abbott, Concord's iconic recreation director, plays opposite Bob Burns in a 1973 production of *Carnival!* directed by Clara Brogan. *Courtesy Paul Brogan.*

lesbian life in this conservative city. Through their work with the Community Players, they had met people of different sexual orientations.

This included Abbott and her partner, Penny Surber. The couple lived together in East Concord and were frequent visitors at the Brogan home. They and others gave the young Paul a glimpse of "normal people living normal lives."

"Betty," he says, "was just Betty." And the town accepted her.

The example of Abbott and Surber clarified what the young Brogan wanted for himself: a relationship rather than a hookup. He remembers walking home from his projectionist shift at the Concord Theatre, late at night, and seeing cars cruising slowly down Main Street. There was no gay bar at that time, no outlet for these men to meet people. So they cruised. "They were creepy, older gay men," he says. "There was more activity than on Friday night shopping. I would count up to twenty cars."

Brogan knew who he was and was comfortable with himself. But he wanted a normal life, like Abbott and Surber, and he found it in his spouse, Alan Jesseman. They have been together since 2005, when Brogan was working on behalf of AIDS patients and met Jesseman, the chair of a support group.

"If you see people in context, then you can accept the other," Brogan observes.

Diversity

Betty and Penny were among our first experiences with what would later be called "diversity." Concord in the fifties and early sixties was pretty homogenous. We had our Greeks, Italians, Irish and French Canadians, we had our Swedes in West Concord and I suppose some of them practiced old country ways at home. But at Rundlett, CHS and Brady, our ethnic backgrounds didn't count for much. We dressed the same, even if our school didn't have uniforms. We went to Howdy Beefburger or the A&W; we read the same books and listened to the same music.

In some arenas, Concord people lived in a bubble, according to Jim Spain. For one, the color issue. "St. Peter's Church and School were 100 percent

Children in the Happy Hollow Nursery School perform an "international" pageant. *Alfred Perron.*

White," he says. "In second grade, the nun brought in this young girl to join our class. Cassandra, her name was. Lovely girl. She was Black, and her father was in the military." While Cassandra only stayed at St. Peter's a year or two, Spain remembers the other children being kind to her.

"I can imagine, as a sixty-two-year-old White man, if I were brought some place and I was the only White kid," he muses. "It had to be an emotional experience for her. But she was welcomed." The Concord kids he knew weren't taught prejudice, he adds. But there were learning curves as the outside world began to trickle in.

There was little to no diversity in Concord in his era, Jim Rivers recalls. "There were one or two African Americans in my class in high school." He was in sports with Jimmy Bacon, a Black boy whose father owned a rug company. There was no racial disharmony, in Rivers's memory, because there weren't that many races.

"I'm sure," he said, "that anyone of color felt uncomfortable." But they didn't express it to Rivers.

Rivers remembers one vacation in Florida as a rude awakening to rudeness. "We were in a Pantry Pride supermarket, and a Black woman was coming out," he recalls. "I held the door for her. A man said, 'We don't do that down here, Yankee boy.'"

Marc Boisvert got his rude awakening in Alabama, at the Southeast Alabama Medical Center, when he did a brief stint as a "traveling nurse." It was in the fall of 1979, and the intrepid Boisvert asked himself, "Where is the scariest place to be?" He chose Alabama, but he only lasted six weeks. "Being kind to Blacks" didn't fit the narrative, he observes laconically.

Boisvert was working a midnight shift in the ER, and he became acquainted with an older Black man who was the janitor. "He was washing walls, and I tried to help him by moving things out of the way," Boisvert says. "He told me, 'No, sir, don't do that. If my boss sees that he'll think I asked you to do it. I'll get myself fired, if I'm lucky.'"

He worked with another woman on the night shift, a ward secretary. She used to be the head of all the ward secretaries, Boisvert recalls, until she "got herself demoted. Her daughter refused to give up her mixed-race child."

"There, the racism was blatant," he says. "Here, it was hidden."

While Brenda Woodfin Thomas doesn't remember any racial problems in Concord, she wishes there had been more opportunities for girls in sports. "I still remember holding on to the backstop at White's Park, watching my brother play baseball and thinking, 'Why not me?'" Thomas recalls.

Young girls perform a Colombian folk dance at Concord's Market Days. The cultural entertainment at this and the multicultural festival in September reflects a growing diversity in the city. *Kathleen Bailey.*

She kept busy with girls' intramural sports, rode her bicycle, took dance classes and made cheerleader at Concord High School. And by the time she had grandchildren, things had come full circle.

"I have three granddaughters," Thomas says. "The oldest plays softball for Coe-Brown Northwood Academy, the second girl plays soccer and the youngest plays lacrosse." Fresh from a CBNA softball game, Grandma reports, "They won thirteen to one."

GROUND CONTROL TO MAJOR TOM

With the exceptions of V-E Day and V-J Day, we were the first of the "where were you" generation. Where were you when Kennedy was shot, where were you when the Beatles played on Ed Sullivan, where were you when Teddy went off the bridge—and where were you when Alan Shepard

rocketed into space. Most of us were in school, crowded into a classroom or auditorium, watching the historic launch on a fuzzy black-and-white TV, with the gym teacher manipulating the rabbit ears. We shared the awe and wonder of the whole country, with an extra dollop of pride: Shepard was one of ours, a Derry boy who rose to have the country—and the world—at his feet.

Shepard rode the Freedom 7 spacecraft, blasting off from Cape Canaveral, Florida, on May 5, 1961. He was propelled into space by a Mercury-Redstone rocket. The Soviets' Yuri Gagarin had already orbited the earth on April 15 that year, but Shepard's flight showed that we could do it, too. It was a unique sixties moment (well, the sixties; what did you expect?), and we swelled with national and statewide pride.

But Shepard wasn't done yet, and he made the moon his country club, famously hitting a golf ball on the moon in July 1971.

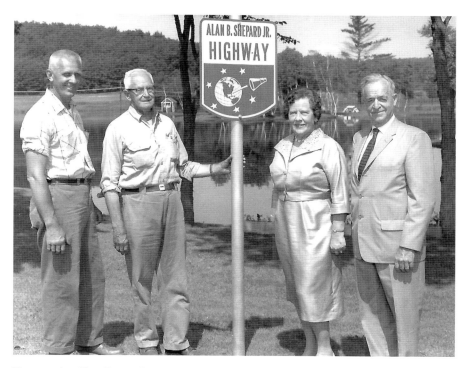

Derry native Alan Shepard came to town in 1962 after becoming the first American in space. He was later to take part in the second moon landing. They still couldn't find Alice Kramden, so what was the point. Here, his parents and uncles represent him as a portion of Route 93 is named for him. *Alfred Perron.*

Shepard didn't spend a lot of time in his home state. He had places to go and things to do. His parents subbed for him as a portion of Route 93 was named the Alan B. Shepard Highway in 1961. The highway was rededicated, closer to the Derry border, on September 16, 2021.

We were also to share in another "where were you" moment when Sharon Christa McAuliffe, another Granite Stater, went down in the Challenger explosion on January 28, 1986. I had a child at home and one in kindergarten, and this became a "where were you" moment for their generation.

Route 93

In our earlier childhoods, going anywhere was an adventure. We took Route 3 to Manchester, and that was fairly easy. But Hampton Beach was an all-day excursion, a circuitous route through Northwood, Raymond, Epping and Exeter, with a packed station wagon. We brought coolers, blankets and enough first-aid supplies to outfit a Normandy invasion. On the way home, we looked forward to an ice cream cone from Johnson's Dairy Bar before collapsing in a sandy heap on our back porches. Our mothers tried to hose us down before we got inside.

To reach the Lakes Region, we went out Route 106 to Laconia, Lakeport and the Weirs. And to get to the mountains, we navigated another maze of country roads, again with the cooler and first-aid kit but with warm jackets instead of bathing suits.

Our main roads would become back roads when President Dwight D. Eisenhower established his interstate highway system. His "Grand Plan" was developed by General Lucius D. Clay and the Clay Committee and presented to Congress in 1956. Though Congress rejected the Clay Plan, Eisenhower continued to fight for a consistent interstate highway system, and in June 1956, Congress passed the Federal Aid Highway Act of 1956.

Like Route 66, our winding country roads became part of history when Route 93 was built. Over a period of years starting in 1957, I-93 linked Methuen, Massachusetts, with Waterford, Vermont, and looped in a good chunk of the Granite State on its way. We could now get to the lakes in half an hour, the mountains in little more than an hour and Manchester in a breathless twenty minutes. Routes 101 and 95 replaced rural Route 4 for beach trips. We could get anywhere faster, and we did.

The expansion of Route 93 North was a momentous occasion, giving the growing community a way to get to the lakes or the North Country without going on back roads. This increment went from East Concord to Boscawen. Seen cutting the ribbon are Mrs. Delores Bridges and her grandsons, Styles Bridges III and Bruce Bridges, with Governor Wesley Powell (*left*) and Senator Styles Bridges (*right*) looking on. Mrs. Powell is at far left. Circa 1963. *Alfred Perron.*

The new highways also streamlined travel to Boston, which before had been its own quirky back road experience. This was good. We liked streamlined. But it also brought in the outside world, with different ways of thinking, feeling and being. We went to Massachusetts, and Massachusetts came to us.

THE MEDIA

My father subscribed to two newspapers, the *Manchester Union Leader* and the *Concord Daily Monitor*. He did freelance work for both, so it made sense, and I earned pocket money by clipping out his photos for filing. The *Union Leader* was a morning paper, the *Monitor* an afternoon one, and while the *UL*

was reasonably professional, the *Monitor* had a hometown feel, even though it was published in the state's capital. Stringers, mostly housewives, sent in "items" for their neighborhood, and in my early years as a reader, it wasn't out of bounds to see listings such as "Daphne Fogg of Boston visited her cousins on Airport Road over the weekend." There were birthday greetings, rummage sales and appeals for lost pets. The type for both papers was set with hot lead and not really adjustable, so if a story came up short, the pasteup guy used fillers such as homey maxims or household hints. Reading the daily was a value-added experience. The daily also had a full slate of comics, including my favorite, *The Jackson Twins*, featuring—wait for it—a pair of beautiful identical twins who got into scrapes, had adventures and, miraculously, never grew older.

My family also occasionally picked up a *Boston Globe*, and my mother became addicted to something called the Confidential Chat, where women from across New England sent in hints and recipes, confided problems or reported on the birds at their feeders. My mother was an avid Confidential Chat follower, although I don't know if she actually sent stuff in. The women all wrote under pseudonyms, and my favorite was, "Tired of Trying." In the 1950s, I can only imagine.

RETOOLING "DOWNSTREET"

It had to happen. Main Street was dying. With the retreat of the five-and-dimes and the mom-and-pops, all crushed by the Kmarts, Walmarts and other marts, Concord had little or no reason to go downtown. Even the tweens were being dropped at the mall instead of at the State House Plaza. In the 1970s, then–city councilor and later mayor Martin Gross summarized it like this:

> *There were empty storefronts, empty buildings, the major commercial tenants were leaving and going out to strip malls, stores that had been anchor tenants of the downtown were out of business or were gone; the supermarkets had all but spun out into the periphery. There was not much to bring people into downtown, and everything was generally falling into decay.*

The Capitol Shopping Center was about to celebrate its tenth birthday.*

* "Downtown Reimagined," "Around Concord," July 2021.

A stately clock tower marks the entrance to Eagle Square. *Sheila Bailey.*

The council knew it had to do something, and it commissioned an architectural study with Guy Wilson. Wilson's report called for, among other things, better signs and more benches, more tree plantings, better lighting and an indoor mall under the James R. Hill Building, the last of which never came to fruition.

A subsequent study called for more "visual delight." A moving sidewalk from Storrs Street to Main Street, alas, never materialized. But after the studies, Concord had a pretty good idea of what would bring people "downstreet" again.

Four major revitalization projects took place between 1973 and 1986: Bicentennial Square, the Firehouse Block, Eagle Square and Capital Plaza. A two-year, multimillion-dollar effort resulted in wider sidewalks; better lighting, including vintage-looking lampposts; pocket parks; and spaces for public art. Main Street became a place to live, work and play, with locally owned boutiques and coffee shops taking the place of the old mom-and-pops. Buskers and outdoor sculpture enhance the experience. Today, on a sunny Saturday in June, one can see people downtown for the farmers' market, at brunch tables spilling out to the sidewalk or simply walking their dogs and their offspring.*

* "Around Concord," July 2021.

Eagle Square, based around the old Eagle Hotel, was an early attempt at making Main Street a destination. It incorporated seamlessly into the later update and is now a place to hear buskers, catch a bus or visit the winter farmers market. *Sheila Bailey.*

The redesigned Main Street raked in several awards, including:

New Hampshire Preservation Alliance 2017 Achievement Award for Outstanding Rehabilitation and revitalization;

American Council of Engineering Companies New Hampshire Gold Award;

New Hampshire Planners' Association 2017 Project of the Year Award;

American Public Works Association Public Works Project of the Year Award;

The Institute of Transportation Engineers Transportation Achievement Award; and

The ABLE-NH Accessibility Award.*

* Concord Chamber of Commerce blog, January 2018.

Concord's retooled Main Street includes benches, plantings, outdoor sculpture, better parking and places someone would actually want to go. *Sheila Bailey.*

The Steeplegate Mall flourished briefly, too briefly, on D'Amante Drive. But it wasn't good enough to compete with the big box stores such as Lowe's and Home Depot, the new wave of discount shops such as Marshall's and T.J. Maxx and especially not with the retooled Main Street. When Sears went out of Steeplegate, that pretty much sealed the deal. The property is awaiting redevelopment and its next usage.*

Downtown has cafés and fine dining. It has the Siam Orchid and Dos Amigos Burritos, vegetarian restaurants and a branch of Cheers, of all things. And it has the whisperings of an arts district. Developer Steve Duprey revamped a building across from the Capitol Center for the Arts into the Smile Building, with apartments for artists and a new home for the League of NH Craftsmen. The Concord Theatre became the Bank of NH Stage, and the Red River, home to foreign, indie and quirky films, settled in across

* See chapter 5.

the street.* The Hatbox Theater operates in what's left of the Steeplegate Mall, serving up intimate performances in a smaller venue.

Jim Spain is OK with the $13 million downtown reboot, completed in 2016, but he knows it will never replace the way things were. "I miss the old Main Street," he says. "It's a piece of our past that we'll never get back." But, he adds, "Progress means accepting changes." But it's hard on "old Concord people," a group in which he includes himself.

Spain has remained active in town in the Knights of Columbus, Capitol City Rotary, as vice-chair of the Heritage Commission and chair of the Demolition Review Board. It challenged him to hold meetings over the demolition of St. Peter's Church, where he and his family had worshipped for years. "I received all my sacraments there," he says.

Before the Great Awakening of historic preservation, Spain was to see other treasures come under the wrecking hammer. "Urban renewal," he says, "took a lot of buildings."

But there was enough of Concord left to make him want to stay.

Rick Tucker also likes the upscaled downtown, though he isn't crazy about the neon lighting at some of the venues. "It looks like Las Vegas," he says.

Ken Jordan is impressed by the way his hometown "stayed alive" through downsizes, layoffs and recessions. "When Rumford Press lost the *Readers Digest*, they laid off one thousand people," he says. "When the railroad depot closed, that lost three thousand jobs." But Concord never sank into decay, instead surviving. "Concord," he says, "never decayed, and it could have."

It isn't the Main Street of our youths, but then it doesn't need to be. Spoiler alert: everybody has cars now. It isn't Portsmouth, but it doesn't need to be that, either. It's a better Concord, someplace we actually want to be.

THE RAILWAY STATION

Urban renewal doesn't always get it right. For every Stewart Nelson Plaza (it's not great, but it's not Carlen's), there's an Old Railroad Station. At least in Concord.

* See chapter 5.

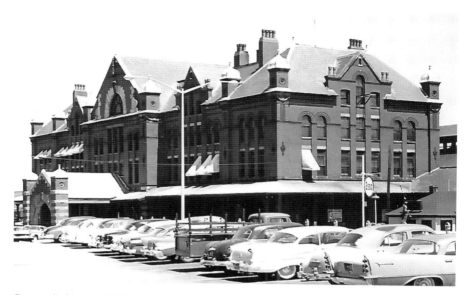

Concord's historic B&M station welcomed returning GIs, Fresh Air children from New York and residents from shopping or theater in Boston. It was torn down in 1959, after the rail era ended. *Alfred Perron.*

The brick fortress was the city's fourth station, built in 1885 and designed by Bradford L. Gilbert, who also designed the original Grand Central Station in New York City. Concord was an up-and-coming city with a need for rail service, in and out. The Boston and Maine Railroad had as many as thirty-two passenger trains in and out of the station, in 1906. But train travel was on the way out—everybody had cars now—and "progress" was looming. Progress in this case turned out to be a bland and generic shopping center, but what did we know. The terminal was torn down in 1959. Train travel stopped and started from a smaller utilitarian structure until it stopped for good in 1967.*

The elegant building remains a memory for those who saw their wartime troops off for service (or welcomed them home), sent a kid off to college, welcomed Fresh Air kids from New York or simply rode into Boston for sightseeing and shopping.

Those who mourn the station have put their efforts toward saving another Concord treasure, the Gasholder.

* Information courtesy of Michael Cosgro, www.nashuacitystation.org.

THE GASHOLDER

The iconic Gasholder is a symbol of the South End to Concord. Built in 1888, it is the last of its kind in the country. In the late nineteenth and early twentieth centuries, the growth of industry around Concord depended on manufactured gas. Liberty Utilities, owner of the structure, had it on a list for demolition, and a grassroots effort has been mounted to save it. The New Hampshire Preservation Alliance is involved and, at press time, was part of a coalition with Liberty and the City of Concord to avoid demolition. The first phase of emergency stabilization was completed at press time. The Gasholder is listed on the National Register of Historic Places and the Seven to Save list (twice) of the New Hampshire Preservation Alliance.[*]

COMING OF AGE IN NEW HAMPSHIRE

It had to stop somewhere. Nobody, not even Concord, could sustain this lack of momentum for very long. For the Concord kids of my era, there was Vietnam,[†] and there were two "where were you" moments before the fabric of our lives was rent for good.

A popular young president, really the first "cool" chief executive any of us had ever seen, and his glamorous wife made a trip to Dallas. November 22, 1963, was an ordinary day for most of us: dads at work, moms dealing with the little kids at home, baby boomers looking at the schoolroom clock and looking forward to the weekend.

At twelve thirty in the afternoon, John F. Kennedy was gunned down by Lee Harvey Oswald as his motorcade passed through Dealey Plaza in Dallas.

The nation reeled. Walter Cronkite cried. The bloodstained pink suit, the single horse with no rider and the tiny boy saluting became part of our memories. But first, we had to live through it.

Paul Brogan was at Rundlett when the news came of John F. Kennedy's assassination. "Our teacher was Mrs. Andrews, and Mr. Richmond, the principal, came to the door," he recalls. "He told her something, and she had to excuse herself. She came back in crying. None of us could have imagined what she had to say."

[*] Information courtesy of the New Hampshire Preservation Alliance.
[†] See chapter 9.

Top: The Gasholder has been a symbol of the South End for 134 years. Faced with its demolition, a grassroots coalition, well, coalesced. The NH Preservation Alliance is now seeking to stabilize and save the building, as part of a South End revitalization effort. *Sheila Bailey.*

Bottom: The Douglas N. Everett Arena, completed in 1965, has brought Concord everything from semipro hockey to roller derby to rock concerts. The arena was named after Doug Everett, a 1932 Olympic silver medalist, for his skill in skating and hockey. *Alfred Perron.*

The Everett Arena continues to evolve with the town's needs. *Sheila Bailey.*

History buffs could comb through musty documents at the state library on Park Street. It still boasts a card catalog for older materials. *Alfred Perron.*

Forever plaid! The St. Paul's School class of 1932. *Alfred Perron.*

The St. Paul's School class of 1927 in funny hats. *Alfred Perron.*

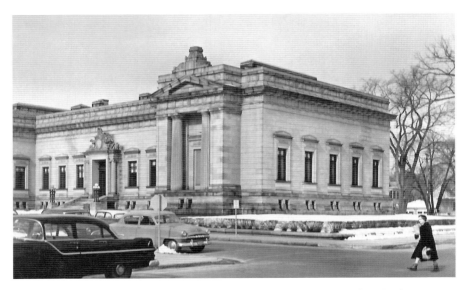

The New Hampshire Historical Society, shown here in the fifties, was a favorite downtown destination when we didn't want to go home, which was most of the time. It had a sweeping marble rotunda and second-floor exhibits, including the Prentiss Rooms, a series of restored rooms using the society's colonial artifacts. We also enjoyed the Concord coach in the lobby. The society still stands on Park Street for administrative and ceremonial functions, but the museum operation has been rebirthed as the Museum of New Hampshire History off Storrs Street. *Alfred Perron.*

The class was a history class, and the students were living history. The school dismissed them, and 1,200 students filed out. "Nobody cried," he says. "It was totally silent." He came home to find his mother had canceled her piano classes, and it was "absolute silence" at the dinner table. Though there was still a sense of unreality, the Brogans accepted the truth when they heard it from trusted broadcaster Walter Cronkite. "He was like your grandfather, sitting you down in the den," Brogan recalls.

School was closed on Monday for the funeral, and in Brogan's eyes, things didn't get "back to normal" until Christmas.

Jim Rivers was in the cafeteria at Rundlett when he heard about the Kennedy assassination. "We were playing football with bottle caps," he says, adding, "One hit me in the side of the head." Detention loomed. But he had bigger things to worry about, as Vice-Principal Carl Bartlett told the students to go home.

The televisions blared all over Concord that weekend, Rivers recalls. He saw Ruby kill Oswald on television, "an image that is embedded in my

brain," he says. Hearing "Taps" played was tough on his mother, he adds, because it made her remember her late husband.

Paul Lillios was quite young when JFK was shot, but even as a child, he knew something wasn't right. "There was a solemn atmosphere," he says. "My parents were distraught. They were watching the funeral service on black-and-white TV, and I was on the floor playing with Lincoln Logs. I was making too much noise, and they told me to 'settle down.'"

Lillios was "four or so," and he didn't know all the ramifications, but he knew something was terribly wrong.

Dolores Robbins Flanders was babysitting the children next door when the news came on the television. "I was horrified," she says. She had admired the young JFK, "and as I got older, I thought about the kind of man he was, what he could have done." When she was old enough to vote, she based her choices on his example, Flanders says.

Flanders had already seen enough loss in her young life, with her father dying when she was thirteen, a family friend committing suicide and a stranger found dead and frozen in the Merrimack River. The series of deaths traumatized the young girl. For months, she was afraid to go to bed at night, "for fear I'd wake up and somebody I loved was dead."

Beatlemania

February 9, 1964. Nobody had to ask, "Where were you?" In all but the strictest homes, anyone under eighteen was crouched in front of their black-and-white television set, or a relative's, or a neighbor's. The Beatles were on *The Ed Sullivan Show*. They sang "All My Loving"; Paul soloed on "Till There Was You"; they did "She Loves You," "I Saw Her Standing There" and "I Want to Hold Your Hand." The audience was electrified. The kids at home were electrified, just like the guitars, while their parents sat in stunned silence or the dad made caustic remarks.

For me, Beatlemania was the first step out of the fifties, even if it came four years later. I loved JFK and Jackie—they put a new spring in the country's step—but they were still my parents' generation, just cooler than my parents. We needed a sixties for us, and we found it in the Beatles. Boys got their hair styled like the Fab Four and formed garage or cellar bands. Girls wrote fan letters, with one of my friends striking up a correspondence with George's mum. We attached near-mystical reverence to objects such as a fragment

of Coke bottle reported to be Paul's, from a Boston press conference. Not a fragment of the True Cross, but it was something. We dressed like Jane Asher and set our watches to Liverpool time.

Paul Brogan thoroughly enjoyed the British Invasion. "That morning, the Sunday of *The Ed Sullivan Show*, Father Quirk told us from the pulpit that we shouldn't watch it. The homily was real 'fire and brimstone.' It made me want to watch it all the more."

The senior Brogans let Paul watch the program, and Ed Brogan did him one better. He had grown up in the same Cambridge neighborhood as the legendary congressman Tip O'Neill, and O'Neill had two extra tickets to see the Beatles in Boston Garden in August 1964. Clara Brogan was a graduate of Juilliard, a classical pianist and a piano teacher. She opined, "That's not music." Ed was up to it and took Paul to the historic concert, though Ed wasn't crazy about the music either. They went to Boston Garden and left by a little-known entrance. Brogan remembers his father saying, "Hey, isn't that one of the guys?" Paul McCartney passed them going the other way, and Paul Brogan got to say, "It was a good concert. I had a nice time." He remembers the "cute Beatle" saying, "Thank you!"

Concord went nuts for the Fab Four, according to Brogan. French's sold out of Beatles albums and so did Britts, the department store in the Capitol Shopping Center. "They sold 150 albums in one day," he says of Britts. Brogan jumped on board. "I was too young for Elvis," he says. "This was the baby boomers' statement music." His parents eventually, reluctantly, accepted the new sound, he adds.

Sandy Pinfield Miller doesn't remember much about the Kennedy assassination. She was at a friend's house when the news came over the television, and she remembers the funeral. But it wasn't talked about at home. "My parents," she says, "were not into current events."

But the Pinfields couldn't ignore a cultural tidal wave: Beatlemania. "I was twelve," Miller said, "and I bought my first Beatle record at French's on Warren Street. It was 'I Wanna Hold Your Hand' backed by 'She Loves You.'" February was her birth month, and the February Fab Four appearance on *The Ed Sullivan Show* was like a gift to her. "I *loved* the Beatles," she says.

Miller also loved the Monkees, but Annie Pinfield wouldn't let her watch them. Brother Jimmy came to the rescue. He was in the army by then and making money, so he bought Miller her own tiny television.

The Boys changed Marc Boisvert's life. In December 1963, he was sitting at the top of the bleachers at Rundlett Junior High School during the last assembly of the calendar year. He glanced over at a classmate, who was

Private Parties Joe-40118
Dances Steve-40203
SNOOPY
and the
RED BARONS

Private Parties Joe-40118
Dances Steve-40203
THE a
HERE n NOW
d

The Beatles changed our lives. While it's perhaps an oversimplification to say the Fab Four brought us out of mourning for JFK, they got kids interested in music, some for careers, some for fun. Here, Marc Boisvert performs with a local group. *Marc Boisvert.*

studying a contraband record album. "It's by a group called the Beatles," the other boy said. The boy and Boisvert sneaked out of the assembly, went to the other kid's house and played it over and over again on a turntable. "I don't even remember the kid's name," Boisvert admits.

But he remembers John-Paul-George-and-Ringo.

The Beatles gave Boisvert focus and purpose. "Up until that time, I had been trying to fit in," he says. He had a DA haircut and "thought it was cool." He put thumbtacks on his shoe soles, to mimic the sound of taps. But when the Beatles showed up, "off came the Vitalis, and I wanted to learn an instrument." He played what would later be known as "air guitar" with his father's old tennis racket, but it wasn't enough. He learned to play guitar.

"I finagled with my mother to buy me a drum kit and promised to take lessons," he recalls. He studied with a Mr. Quimby, a percussionist with Nevers Band,[*] on the third floor of the old Acquila Building. Boisvert eventually graduated to a Ludwig drum set, "the kind Ringo had," and formed a band with his brother, who had also begun to play guitar.

They called themselves the Sun Chasers, after the B-4 hit "I'll Follow the Sun," and they played all over Concord until his brother graduated. Their farewell concert packed Brady and alarmed an administrator.[†]

[*] See chapter 5.
[†] See chapter 3.

Here's Ian Chisholm with his Beatles haircut. He got called to the principal's office twice and ordered to cut his bangs. *Ian Chisholm.*

Our worlds would be cracked open in another way with the phenomenon known as Motown. Young people whose skin didn't match ours sang of the same joys and frustrations of teen-hood that we were experiencing. Motor City music had us all dancing in the streets, and really, who could go back from that? It wasn't Dr. King, but it was something.

The Beatles evolved, and so did we. The songs stayed on, from elevator music to a surprisingly good rendition of "I Wanna Hold Your Hand" by the Boston Pops. They put out two decent movies, *A Hard Day's Night* and *Help!* We traipsed after George down his Eastern mysticism path. Some came back; some didn't. We went on the trip of *Sgt. Pepper* and the darker trip of *The White Album.* We grieved the deaths of John and George and mourned when Paul lost Linda. They weren't always perfect, but we took what we wanted and left the rest.

And I still remember one March afternoon, heading toward spring, with a mild wind in the trees and slush from the last snowstorm on the Heights sidewalks. I ran into four girls I knew, arms around each other, singing at the tops of their lungs, "Close your eyes and I'll kiss you, tomorrow I'll miss you, remember I'll always be true."

As good a harbinger of spring as there ever would be.

Chapter 8

THE RECKONING:
RELIGION, POLITICS AND VIETNAM

RELIGION

Concord in the fifties and sixties was a city of churches. Nearly everyone "went" somewhere, and where they went was one of their identifiers. Spires dotted the city skyline. Blue laws contributed to keeping the Sabbath holy, and on Sunday afternoons, "downtown" was "ghost town."

The Irish, Italians and French Canadians migrated to the North End, or "Fosterville," and worshipped at St. Peter's Church. But there were neighborhood Catholic churches all over the city. Catholic schools, mainly St. John's, St. Peter's and Sacred Heart, molded good little Onward Christian Soldiers, to be scooped up by St. John High School and its later iteration, Bishop Brady. Eventually, the Age of Aquarius and dwindling vocations shrunk the Catholic school scene to St. John's Regional School and Bishop Brady High School.

While some kids rebelled, especially during the later sixties, the routine of church provided calm and stability for others. Sandy Pinfield Miller recalled an "all's right with the world" feeling as she walked to St. Paul's Episcopal Church "with my little hat and straw purse."

As a small business owner, Jim Wentworth's father worked seven days a week, Wentworth says. But Edna Wentworth was the organist for the Immanuel Community Church, a small nondenominational church on the Heights, so the Wentworth kids went to church and Sunday school. "It was a kind of generalized Christianity," Wentworth recalls, and did not impact his later life. "It was something I did."

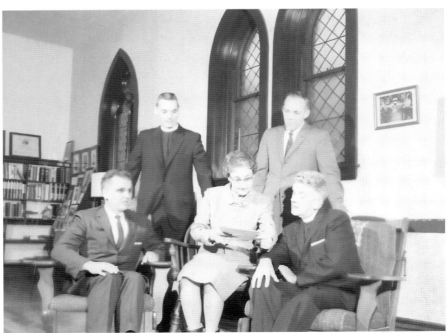

Opposite, top: The Catholic Daughters of America held this Living Rosary in September 1961. *Alfred Perron.*

Opposite, bottom: St. Paul's on Park Street was and is the meeting place for Concord's Episcopalians. *Alfred Perron.*

Left: St. Paul's Church maintains a dignified presence on Park Street. *Alfred Perron.*

Paul Brogan's family liked Angelo's Restaurant and the hospitality of the Arata family. One Brogan family ritual was going to Angelo's sometime before Ash Wednesday, so they could get their fix of spaghetti and meatballs.

Lent was a big deal for the Philbricks, and Mike Philbrick remembers going out for Friday night seafood at the Inland Lobster Pool or Keniston's by the river. "My father was kind of a stickler," he says. "He did not like the smell of fish cooking. So we ate out."

The Sisters at St. John's were another matter, according to Jim Rivers. "They had the attitude that if you were Catholic, you were the best," he says. His sister later married an Episcopalian, at St. Paul's Church, and Rivers recalled feeling "guilty" as he walked into the building.

He went to Graham Junior College in Boston, majoring in broadcasting management, and mixed with other races and religions. But Boston wasn't a

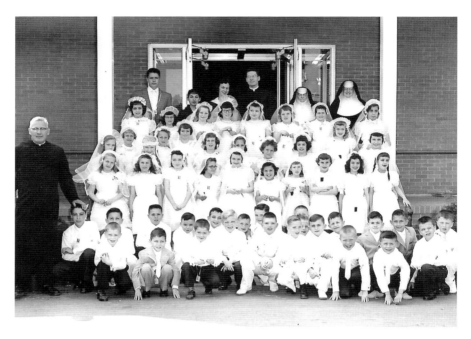

Above: First Communion was a big deal in the fifties, and nowhere more so than at the brand-new Immaculate Heart of Mary parish on the Heights. *Alfred Perron.*

Opposite, top: St. John's Church on south Main Street during its heyday. After the closing of St. Peter's and Sacred Heart, St. John's, reborn as Christ the King Parish, was the only Catholic church on that side of the river. *Alfred Perron.*

Opposite, bottom: The Reverend Richard O. Boner (*center*) and his curate the Reverend Hector Lamontagne chat with members of the local Catholic Daughters organization in 1962. Despite his unfortunate last name, the senior pastor built Immaculate Heart of Mary Parish from the ground up with his energy and charisma. *Alfred Perron.*

culture shock, Rivers says of his college years. "I just went with the flow." He had a friend in school who was a Jewish man from the Bronx, and they would talk for hours, he said. "He got me hooked on bagels and lox." He learned that Catholicism was not the "be all and end all," according to Rivers.

Rivers, looking back at his Catholic school education, says thoughtfully, "It *was* kind of brainwashing. But St. John's gave us a good foundation." Even though he "got it across the knuckles" more than once from an exasperated Sister of Mercy.

Religion had no impact on Frank Perron's life. His mother's family was Catholic; his father's family didn't attend church. His mother rebelled against her Catholicism and brought the kids up Unitarian, but even that didn't take

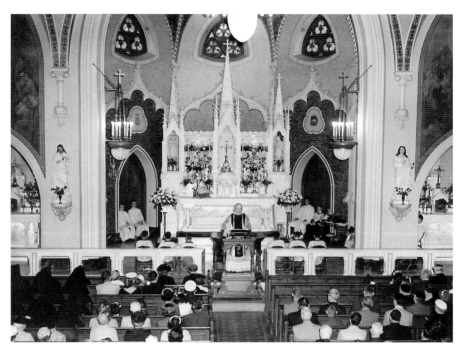

with Perron. "I've been an atheist all my life," he says. When they were prep school shopping, he interviewed at St. Paul's but pulled himself out when he heard about the mandatory chapel.

Religion didn't take with Fred Walker, though he attended Catholic school by choice. It wasn't enforced at home, he said, and he didn't believe everything taught by the nuns and priests. "I maintain to this day—it's impossible," he says of some Catholic doctrine.

Ginie Murphy says simply, "We did not go to church."

Allan Stearns's family did. At First Congregational Church in downtown Concord, he fostered his love of music. He was already in the Rundlett band and would be in the Concord High School band, but he also sang in choirs and ensembles at First Congregational. Dick Gagliuso, his high school band director, was also involved in music at the church, Stearns says. The deeper lessons of his faith stayed with Stearns, and his late-in-life career is ministry.

Kenneth Bly's family was deeply involved in Grace Episcopal Church in East Concord. They went every Sunday, and he and his brother participated in Sunday school and youth group events. He was confirmed at the larger St. Paul's Church in downtown Concord.

The Episcopal church was a compromise for the senior Blys, according to their son. "My mother was a staunch Catholic, and she married a Protestant, so there were issues," he says. His parents were together since high school but did not marry until 1950, owing to resistance from his maternal grandmother. "She would not," he says, "allow an interfaith marriage." After the pious old woman passed, James Bly and Alicia Silva were finally able to marry.

"At Grace Episcopal, they found common ground," Bly says.

He went to church more or less up to his marriage, since he lived at home into his twenties. He grew away after marriage, but when he and his wife lived in Mystic, Connecticut, they "got back in" as Congregationalists and raised their children in the Congregational church.

For Omere Luneau, Catholic school was a place to ask questions, though not necessarily about the curriculum. The Sisters did give him a good founding in the three R's, from grades one through eight, and Luneau is grateful for that. But he didn't like it "when they tried to ram Jesus down your throat. I questioned that early. I questioned their authority, and how they expressed concern for the poor yet spent money on things like chalices and their investments."

Luneau traveled a long road, spiritually if not physically, through demons of addiction to AA. Along the way, he found a different Jesus than the one the Sisters taught. "It's not the Jesus the priests rammed down your throat,"

A group of determined confirmands at Concordia Lutheran Church in 1964. Onward, Christian soldiers! *Alfred Perron.*

he says now. "What this Jesus is looking for is the same thing I'm looking for—union with God."

Luneau believes in a power greater than himself and says, "It was always there."

In rehab, he got to know a priest, Father Martin, and remembers the good Father's statement: "Faith can move mountains, but you'd better bring a shovel."

There's a God-sized vacuum in everyone, Luneau believes, and he's filled it with a different Jesus than the one he was taught in childhood.

GETTING OUT THE VOTE

In Concord, we were uniquely positioned to watch politics. We were the state capital, after all, and we had the first primary election in the nation. Everybody came here to stump on the street, in local diners or at the New Hampshire Highway Hotel, a rabbit warren of rooms right off the traffic circle. There were formal dinners and meet-and-greets. Others met their public in the crumbling Eagle Hotel.

Allan Stearns remembers being sheltered from the "outside world" but learning more about politics and how things worked as he grew older. "My mother and father were Democrats, so I decided I was a Democrat," he recalls, adding that there was more collegiality and more "back-and-forth" in those days' politics.

Above: New Hampshire has fought to preserve its first in the nation primary. This sign near the state library explains some of the background. *Sheila Bailey.*

Opposite, top: Candidate JFK meets with the Postal Union. *From left*: Horace Sanders, representative of Retired Civil Service Employees; Vincent Marsh, Executive Board of the State Association; John F. Kennedy; Roger Watson, secretary of Branch 72; John F. McGrath, letter carrier; and Adrian Cote, president of Local 279. *Alfred Perron.*

Opposite, bottom: President Eisenhower comes to Manchester. This isn't a Concord photo, but what baby boomer doesn't remember saluting the president with a glass of milk while watching a popular kids' television program? It was what you did. *Alfred Perron.*

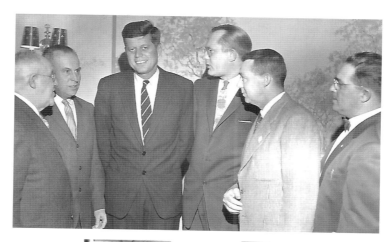

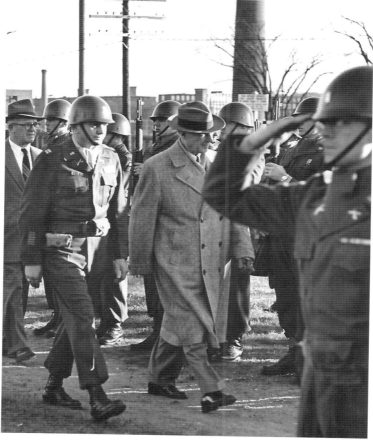

Above: Democrat dinner at Highway Hotel. *From left*: Chester Bowes, congressman from Connecticut; Frances Adams of Exeter, National Democratic Committee; Bernard Boutin of Laconia, National Democratic Committee; Madeline A. Gladu of Manchester, state chairman Women's Division; and attorney Murray Devine, Democratic state chairman. *Alfred Perron.*

Right: Granite Staters throng the hall of the State House for the inauguration of Governor Wesley Powell. *Alfred Perron.*

Stearns's father took him to a rally for John F. Kennedy in Manchester, and he remembers cheering for Kennedy in a snowstorm. "It was November 6, 1960, and I was so thrilled," he says. Camelot was within reach, at least for the young Stearns.

He also remembers the Goldwater/Johnson contest of 1964. The seventeen-year-old Stearns heard Goldwater speak live and remembers telling the Arizona senator, "If I was old enough to vote, I still couldn't vote for you because I'm a Democrat." Goldwater's response is not on record.

"I didn't recognize the differences between Democrat and Republican because it wasn't important," Stearns recalls. "They never argued like you see today. Now you have to blame everybody."

WHEN MCCARTHY BECAME AN "ISM"

In the early fifties, the country was in the talons of something called McCarthyism. Our parents followed the House Committee on Unamerican Activities hearings on the eight-inch television atop a metal stand in the living room. The paranoia didn't spread to the Granite State, at least not much, but it was gripping to watch on a national level.

Some of us feared communism more than others, and an Epsom woman, Barbara Anderson, made her feelings known with the famous Trojan Horse installation. Though the horse went up in the seventies, it encapsulated the feeling of the fifties and early sixties regarding communism. The wooden trojan horse presided over forty-two white gravestones, meant to represent the "captive nations" under communism. The trojan horse added to the ambience of Route 4, the famed "Antique Alley," until weather and neglect took their toll. When Billy and Sandy Boulanger of Hopkinton purchased the former inn, they removed the horse to their private property for its safety.

Herbert Philbrick of North Hampton, then a Boston advertising executive, volunteered as a counterspy against communist influences. He successfully infiltrated the Communist Party in Massachusetts from 1940 to 1949, acting as a double agent until he testified against the party in 1949. He "led three lives" as citizen, Communist Party member and counterspy for the U.S. government. *I Led Three Lives* was the title of his bestselling book in 1952 and a television series running from 1953 to 1956. He returned to North Hampton and worked at various jobs while continuing to lecture about and against communism.

Carol Foster of Nashua had a lower profile. As a wife, mother and professional photographer, Foster had enough to do. But when she met an FBI agent in 1945 (in, of all places, a PTA meeting), she asked half-jokingly if there was anything she could do to help fight the spread of communism. There was, and in 1947, Foster joined the Communist Party of Nashua, rising to the position of secretary. She reported on the party's activities for thirteen years, even taking photos at meetings. In 1958, she testified before the House Un-American Activities Committee, and her spy career ended. She continued in photography, at one point heading the New Hampshire Professional Photographers Association; continued raising her family; and died in 2007 at the age of ninety-three. History will finish her chapter and Philbrick's, judging whether they did the right thing or did the wrong thing too well.

But Red Menace aside, things were pretty peaceful in Concord in the fifties and early sixties. We analyzed bland, two-hundred-word current

And who could forget the Trojan Horse in nearby Epsom? Barbara Anderson installed it on her property in 1977 to protest the United Nations, surrounding it with white crosses representing communist countries, or, in her view, the graveyard of democracy. *Alfred Perron.*

Carol Foster, a counterspy against communism, receives a commendation from Commander Alexander Gifford Jr. at American Legion Post 21, Concord, on May 15, 1958. *Alfred Perron.*

events articles from our *Weekly Reader*, a children's news weekly. We clapped when the veterans marched in parades, and we marched in a few ourselves, but our fathers protected us from most of the gritty details of World War II, including why they fought and what they found. We planted a tree in Israel, and we read *The Diary of Anne Frank*, but our knowledge stopped in the Franks' attic hideaway. Nobody told us what happened in the camps. We were too young to understand the Nuremberg Trials, and unless we had a big brother or an uncle deployed, we didn't worry about Korea. If your parents were Democrats, you were most likely a Democrat; if your parents were Republicans, you were most likely a Republican.

Until everything blew open and nobody knew what they were anymore. They just knew what they weren't.

NO GOING BACK

Dolores Robbins Flanders remembers talking to her "best friend" Tom Saltmarsh as he worked on the roof of the Goodyear tire company. "He had just gotten married, his wife was pregnant, and he had just gotten the word he was going to Vietnam," Flanders recalls. "He looked down at me and he said, 'I don't think I'm coming back.'"

Saltmarsh was seventeen. He never returned, and Flanders remembers attending his funeral, along with those of six or seven other "Heights guys."

The war in Vietnam actually began in 1946, but it wasn't a household word—or expletive—until the mid- to late sixties. The war divided American society: hawks from doves, parents from children, Okies from Muskogees. Patriotism was on the line, with fathers who fought Hitler invoking the same principles. Television brought that conflict into our living rooms, through journalists like Walter Cronkite who couldn't hide behind propaganda because the images were there for the taking. A naked, crying child running down a village street. A North Vietnamese soldier with a gun to his head. And an American college student keening over the body of a fallen friend.

The placid children of the 1950s began to ask, "Why?"

The outside world was creeping into the quiet state capital, and the fabric was beginning to tear. One indication of the turmoil in the country: the so-called Critter Corner at the corner of Pleasant and Main. Long-haired youths would gather there to protest the war or just hang out. "They were 'hippie types,'" Mike Philbrick recalls, "and people were afraid of them." It got to be so bad, at least in the eyes of the "town fathers," that then police chief Walter Carlson put on a special detail from midnight to eight o'clock in the morning.

Vietnam was the fulcrum for the forces that would increase awareness of civil rights, women's rights and the right of youth to a voice. Philbrick remembers his parents talking about the war. "No one could come up with a good reason for why we were there," he recalls. He was a police cadet and recalls the mood at the police department as generally supportive of the war. A musician, he also played gigs at the American Legion and the VFW, and he listened to the talk. "I came out of the clubs thinking, 'This war is not right.'" Philbrick wanted to support his government but knew "something ain't right here." He was still young and didn't speak up. "I wanted," he says, "for everyone to be happy."

Philbrick saw friends die, including Tommy Saltmarsh, the brother of his friend Jim Saltmarsh. His uncle did a number of tours in-country, "but he never wanted to talk about it," Philbrick says.

And nobody ever pinpointed "whether we won or lost."

Sandy Pinfield Miller was working in Washington, D.C., at the time the Vietnam Memorial Wall was built. She remembers seeing the names of many "Concord guys," observing, "We lost a lot of friends."

Miller's first husband served in the navy during the Vietnam years but didn't get deployed. But the war still hit close to home when her older brother Jimmy was drafted in 1969. He went to Fort Dix for basic, then to Fort Monmouth and finally to Vietnam. Jim Pinfield was shot and came home with a 100 percent disability rating. He continued to recuperate at Fort Devens in Massachusetts, and the family visited him there for a year before he was discharged. Though he survived the war, he was never quite the same, Sandy Miller recalls, and he died at fifty-nine from bladder cancer.

Jim Spain's brother, Richard, was five years older and enlisted. The entire family went to see Richard Spain off from Boston on an October day. "My mother was crying," Jim Spain recalls.

Richard trained as a pilot and was a member of the Black Aces. He survived Vietnam but at a cost: he suffered severe anxiety for the rest of his life. "Today we'd call it PTSD," his brother Jim says. But Richard got a job with the post office and managed to live a full life, Jim adds.

Spain remembers friends, cousins and members of his Scout troop who served, some never to return, some to return irreparably altered. "The cocoon we lived in was ripped apart, exposed like an old wound," he says.

As an adult, Spain finally came to terms with Vietnam. "The world leaders have not learned," he says. A fervent student of history, he's observed the same mistakes in most major wars, including the trench warfare of World War I, where his maternal grandfather served, and as far back as the Civil War.

James Pinfield of Concord joined the army in 1969, was shot in Vietnam in 1970 and spent the next year in the hospital, three months in Camp Zama, Japan, and nine months in Fort Devens, Massachusetts. *Sandy Pinfield Miller.*

David Sayward remembers the Vietnam era. "The sixties unfolded here just the way they did around the country," he says. "My mother was in an anti-war march. Someone called to her, 'I can't believe you're doing that, Norma!'" And his mother called back, "Don't you want peace?"

Jim Wentworth turned eighteen in 1971 and was issued his draft card. He had the number 230 and his best friend, Gary Smith, had 232. They joked about it. But neither got drafted—the war stopped before they had to go. His brother's friends were not as lucky, and he remembers mourning Doug Stover and Tom Saltmarsh.

His brother John graduated in 1967 and enlisted in the navy; he was stationed in the Mediterranean for two or three years. Their older brother Bob enlisted in '64 but received a medical discharge.

Wentworth voted for Nixon because of Nixon's promise to end the war. "That wasn't the smartest choice ever," he muses.

"The war," he says, "was idiotic."

Ginie Murphy's brother Bill was seven years older than she was, and he did go to Vietnam. He was in the navy and stationed along the Mekong River. Murphy, who had pen pals all over the world, tried to write to him, but even a seasoned correspondent like her was stumped. "What should I say? And any letter I wrote would follow him around for a month before it got to him."

Murphy was still young, and she didn't dwell much on Vietnam. "I'm sure my parents were worried," she says, adding that she probably thought about it more than other kids without relatives in-country.

Karon Devoid thought about it a lot. Her brother Kirk and her husband, Phil Royce, were both deployed. She and Royce kept up a correspondence during his Vietnam hitch and were married when he came home. The young couple was sent to a base in Minot, North Dakota, a place even colder than New Hampshire, according to Devoid. The Canadian border stood in proximity, and Devoid saw "a lot of AWOLs, some because of the weather, some because of Vietnam."

Vietnam affected Devoid's young husband. They married within two or three weeks of his return, but "he was already a different person," she says. "It changed him. His sister convinced him to get counseling, but he didn't get a very good counselor." Her brother Kirk, however, wasn't as affected by his deployment and came home and lived a full life.

Royce was eventually deployed to a base in Arizona. The Devoid-Royce marriage ended, but she stayed on in the West for several years. Working on base, she saw myriads of other young men, both before and after deployment. "Some of them could talk about it. Some of them could not. Others used

it as a crutch." She's seen servicemen spit on when they returned from Vietnam, and it marked her.

Today's soldiers have it easier, with FaceTime and more frequent furloughs. Though Devoid doesn't deny their sacrifice, the phrase "thank you for your service" makes her "cringe" after the Vietnam experience.

Jim Rivers did not go to Vietnam, though he was drafted. "I flunked the physical—I had a knee injury," he recalls. But as a journalist, he marked the impact on his home community. "It had a great impact on a community our size," he says. Wayne Provencher, a St. John classmate, was killed in Southeast Asia along with six or seven other of his friends. A cousin in Lancaster never came home, Rivers says. The cousin's wife was pregnant at the time, "and she had a baby girl he never saw."

Rivers says today that Vietnam was "a needless war, and never should have happened." World War II was different, he says, "because they were fighting for something." Losing so many young men cast a "pall" over Concord, according to him.

Rivers did not publicly protest the war, but he had his own thoughts. "The sad part is, when a lot of these guys came home, they were mistreated," Rivers says, adding, "I have a lot of sympathy for the vets."

Rivers had his own way to process the events of history. He was working for his college radio station when Martin Luther King was assassinated and when the National Guard gunned down four students at Kent State.

Those, as Rivers sums up the period, were "turbulent times."

Frank Perron's father was a doctor, "and he was against the war," Perron remembers. "He did everything he could to help young guys get out of the draft."

But the local draft board knew exactly what Frank Senior was doing, and according to his son, "They took it out on me."

The local draft board consisted of merchants and businessmen Perron had known all his life. "They called me a traitor, a coward," he says of his efforts to receive conscientious objector or CO status.

Perron was at Harvard by this time, and he took advantage of Harvard's anti-draft lawyer. The attorney's counsel was magnificently subversive. "He told me to send the draft board something every day—a painting, a page from the phone book," Perron notes. "Whatever they got, they had to stamp it and put it in my file. Eventually I sent them something important, and they put it in the file and didn't look at it."

The strategy, Perron explains, was to bombard the draft board with meaningless communications so "they would get into the habit of just

putting my mailings into my file without looking at them. Then when I sent them something important (like a request for an appeal) they would put it into my file without attaching a response to whatever I was alleging. Then my mother copied the file and sent it to my lawyer."

Perron underwent yet another physical, "one where the buses were idling outside waiting to take us to the induction center," he says. "We were asked if anyone was refusing induction, and my hand went up. I was classified 1-Y and sent home."

Perron continued to actively protest the war, at Harvard and at a number of events in Washington, D.C. He was a member of the Cambridge draft resistance group.

He says now, "I feel that everyone from that time is a veteran in some way. There was such stress."

But Perron notes that the war and subsequent fallout brought a new awareness to the country, with Black troops coming home determined to have better lives and notables such as Muhammed Ali stating, "I ain't got no quarrel with no Viet Cong."

It was a watershed time for many and a time that changed America, Perron says. And the discussions are still going on. "I'm in touch with some of my classmates from prep school. They're right-wingers, and we still argue about it," he says.

Marc Boisvert learned early on the price of sticking to his beliefs. As a sophomore at Bishop Brady High School, he became friends with a senior who had "communist leanings." "He showed me some literature, he showed me the *Daily Worker*," Boisvert recalls. The Reverend Norman Limoges, a Brady administrator at the time, heard about the exchange. He did nothing to the senior, but he called Boisvert on the metaphorical carpet and told him not to bring peace literature on the school campus. According to Boisvert, Limoges said something to the effect of, "Peace literature doesn't belong in a Catholic high school." Boisvert persisted, resisted and was expelled.

He had other issues and attended a number of schools, staying with different relatives around the state. "Pembroke Academy said if I left, they would pass me," he recalls with a shrug. He tried Concord High School twice, but when he started a peace newsletter, the administration quashed it. "That's censorship," he remembers thinking, but nobody listened. He eventually passed what was then known as the GED, with 99 percent success, and he was "out of there," he recalls.

Discussion of the Vietnam War and its issues would eventually find its way to high school classrooms, but it was too late for Boisvert. He next

had to focus on not going to Vietnam himself, a problem exacerbated by a draft number of forty-seven. By then, he was an orderly at the former Sacred Heart Hospital in Manchester and found that he enjoyed helping sick people. He negotiated a deal with the School of Nursing. "I had a horrendous educational background, but I said, 'I'll pay the first-year tuition. If I don't do well in the first three months, you can keep all the money.'" The school agreed.

He was friends by then with Virginia Colter, operator of the Peace Center on Pleasant Street, and he consulted with her. "She told me to go for conscientious objector," Boisvert recalls. He tried to fail the induction test, but that didn't work. Assigned to a preinduction physical in Manchester, he was classified 1-A.

But an act of God, or at least the weather, intervened. Boisvert was at work at Sacred Heart when a big storm came up. He slipped and fell in some rainwater while trying to close a door, and one of the nurses spotted the accident and hauled him off to the ER. His doctor in the ER was an amiable Filipino man who said, "Are you going to Vietnam?"

"I told him, 'Yes, but I don't want to go,'" Boisvert recalls.

The doctor began poking Boisvert. "He would say, 'Does that hurt?' and I would say, 'No.'" Then he'd tell me, 'Yes, it does.'" The upshot was that the doctor wrote a report and Boisvert took it to the draft board. "By now, they hated me," he says. But in three weeks, he received a notice changing his classification to 4-F.

He says now, "I don't know if I was physically, mentally or emotionally unfit." But he stayed stateside, received his nursing degree and worked at the profession he had come to love.

Omere Luneau went back to high school to avoid the war. When he could no longer stall the draft board, he faked a drug dependency to exempt himself. "I didn't have the money to escape to Canada, and there was no way I was going to Vietnam," he says.

Paul Brogan remembers the Vietnam War, and in his memory, Concord was split. "Some people said we had no business being there. Also, it was too far away for a lot of people to really 'connect.'

"It was not a traditional war. It was totally different, with a lot of confusion."

He personally had "grave concerns" about the United States' involvement, he said. By then, even a Catholic high school could not avoid the war. It was the main topic of discussion in his Brady social studies class, taught by Sister Irene Hathaway, and part of a pivotal year in which RFK and MLK

Paul Brogan served briefly in the navy. He is seen with his parents, Clara (*left*) and Edward. *Paul Brogan.*

were shot. "The father of one of the students called Father Limoges, the administrator," he says. "He didn't like the idea that Vietnam was being discussed in class. He didn't approve of the U.S. involvement."

Several of Brogan's classmates died in the war, and other people he knew from around Concord did not come home.

Vietnam had already cast its shadow over America when Brenda Woodfin Thomas and her future husband were in college. Brad Thomas knew some kind of service was inevitable, so he joined the school's ROTC. "He figured he would go in as an officer," Thomas says. He did, and he secured a position as a courier. "He carried top-secret documents across the country," Thomas says.

Brad didn't have to go to Vietnam, but the stateside position was scary in its own way.

Joseph G. Boucher 111, U.S. Army SP4 E4 First Battalion Twenty-Fifth Infantry Division, Wolfhounds. The Concord High School graduate was stationed in Cu Chi Republic of Vietnam from November 1966 to October 1967. He was the son of Mr. and Mrs. Joseph Boucher of Joffre Street. *Celine Boucher.*

"He didn't have to go himself, but as an officer he had to send people to Vietnam," Thomas recalls. "It was a scary time. I lived it every day."

Though Brad was spared, Thomas remembers asking herself, "Why are we even there?" and being moved by the images of the Last Helicopter.

Her sons are forty-nine and fifty-one, and she often tells them "how lucky they are that they didn't have 'their' war."

Ken Jordan knew he would have to serve, and he wanted to make his own choice. He graduated high school in 1959, worked two years and learned about the Coast Guard from a neighbor who had enlisted in that branch. Jordan wanted a branch that had "something to do in peacetime," and the Coast Guard, with its many responsibilities, was a good fit.

Jordan served during the Vietnam era but was not harassed, though he heard about it from other members of the military. But it wasn't a "thank you for your service" time for him either. He often hitchhiked from Boston to Concord, in uniform, and remembers when one ride dropped him off at one end of Elm Street in Manchester. He had to walk the length of Elm Street to meet his other connection, and "I didn't get hassled. But I didn't get respect, either."

Allan Stearns was within a month of graduating from UNH when he got his "greetings" letter in May 1969. He headed off to Manchester for the preinduction physical. "If you had two arms, two legs, two eyes and they all sorta worked, you got drafted," he recalls. The army, navy and marines took draftees, not the air force. "So I hustled over to the air force office in Portsmouth." Stearns was informed that he wasn't needed unless he qualified to be a pilot. Stearns persisted and was accepted for officer candidate school because of his college degree. He received the rank of lieutenant, and though he failed at pilot training, the air force offered him several career options.

"I chose munitions officer," he said. It was his "golden ticket" away from the front, though he did spend eighteen months in Southeast Asia, specifically Thailand. He visited Vietnam as part of his duties and observed combat, but he wasn't *in* combat.

Stearns had a high-level job and received a Bronze Star, he says. And after his initial four years, he elected to stay, retiring after twenty-five years as a lieutenant colonel.

One classmate from CHS died in Vietnam. He was a helicopter pilot in the army and "died doing what he loved," Stearns recalls.

Stearns experienced the country's resentment of the war when he came home, flying into San Francisco. "We were accosted," he says, "with words and with items thrown at us. We were called baby killers." In the days that followed, he felt shortchanged, he says, noting, "We didn't go to Canada. We didn't burn our draft cards. We did the right thing."

"We had," Stearns says, "a job to do."

And he didn't know it included being called "baby killers."

Stearns says he feels respect for today's active military but also a sense of resentment.

"It's a sad, sad page of our history," he says. As a historian, Stearns knows how we got there.

And he paid his dues. He was exposed to Agent Orange, had cancer and is now a combat-related disabled veteran.

His Vietnam experience fueled Stearns's final career. "I'm an unordained minister, and I've conducted many funerals. It's a 'calling' that came to me later in life, and it's most rewarding. Everybody deserves to be happy."

Flanders, who found everything she needed in the Concord area, was around for the funerals of most of her classmates, and she made sure they were remembered—the right way. She remembers camping with her family in Canaan and hearing someone at another campsite dumping on Vietnam and those who served. "I lit into him," Flanders says. "I said, 'You have no right to talk like that.' This country was wrong in how it treated them."

And it's the happy memories she'll dwell on. "I remember Tommy Saltmarsh's parents had a black Lincoln Continental convertible, and he took me for a ride in it. We went speeding up Route 106. I was screaming and begging him to slow down."

POSTSCRIPT

It had to end. Some people left Concord for college or the military and never came back. Some left for greener pastures or any pastures, returning in their later years. Others, like Jim Spain and Dolores Flanders, knew a good thing when they had it. Spain had a major role with a major corporation, but he insisted on raising his family in Concord and traveling for his work. Flanders got as far as Bow before she moved back to the city and eventually to another part of her beloved Heights.

They all took Concord with them, and sometimes Concord met them wherever they went. After high school, Flanders worked for the state and Blue Cross/Blue Shield (BCBS) before taking up nursing. BCBS wanted to send her and a colleague to Boston to train on computers. The two young women rode down in Flanders's Mustang convertible. "We got *so* lost," she recalls. "We felt like country hicks."

In her desperation, she looked around her, and saw a Concord boy coming down the sidewalk. It was Larry Clark, a boy who had joined the navy, strolling in full uniform.

"We said, 'Larry, Larry, can you help us?' and of course he did."

Concord taught Flanders to go after what she wanted. Though she worked briefly in the clerical field, including on some early computers, her heart was in nursing. "I didn't settle," she says now. "I wanted my life to be different and better." Concord "pushed me, and I tried to take advantage of opportunities," she recalls. She did strive for something more and served as a nurse at Concord Hospital for forty years.

Fred Walker worked thirty-four years for Universal Packaging, until the factory got bought out. The "family feeling" was gone for good, he says, and "I learned to stay away from corporate America."

But not from Concord. Walker has spent most of his life in and around the capital. "It shaped my character," he says, "by me having the friends I've had. Their parents were there for you, too. I can remember my friends' parents coming by White's Park and tossing a ball with us."

Rick Tucker also stuck around. He worked for Rumford Press, Norm's Gulf and Artisan Plastics and spent twenty-five years in Chichester before moving back into the city. He now lives in Portsmouth and rents out his Concord condo.

He's not sure his lessons came from Concord specifically but rather from the times: "I learned the value of a penny and a nickel," he says.

Ken Jordan will always remember the inclusivity. He was not good at sports, he says emphatically. But his friend Harvey Smith was and encouraged the young Jordan to try out for Little League. Though he did not make the team, Jordan was installed as bat boy and junior manager and was a full participant and honoree when the team won the city championship.

At St. John's High School, only twenty-two boys wanted to play football, and Jordan snagged a spot on the second-string team. In four years, he played in "maybe two games," but again, he felt part of something, and he even earned letters from the sport.

After receiving an associate's degree in welding from Manchester Community College, Jordan moved to Groton, Connecticut, to work on electric boats. He married a Connecticut girl in 1976 and worked on the electric boats for two years before falling victim to a "workforce reduction." He and his wife moved to New Hampshire, where he worked for the former Lyons Ironworks and at various welding jobs. The family returned to Connecticut, and he also worked briefly in Midland, Michigan. He also worked as a national certified welding inspector and retired to Londonderry. Jordan has fond memories of an earlier Concord, where he walked up and down the country club road shooting squirrels.

Omere Luneau went on a trajectory of drugs and alcohol. He was arrested for desecrating the American flag. "I was working in a sawmill, and the owner gave me a cabin to stay in," he says. "It had these bare walls." So he pulled down a flag from outside the State House, in order to have something to decorate his wall. "Suddenly," he said, "cruisers were coming from everywhere." A police officer had been stationed near the State House in anticipation of a drug bust. They got a flag bust instead. It was a low point for Luneau.

Luneau had a "good woman" at the time who was loyal to him, visiting him in jail, and he began to turn his life around. He was friends with Winifred Wingate, his old guidance counselor at CHS. Wingate's son David Emerson taught Luneau the builder's trade. Luneau worked for Emerson for four years before going out on his own. Omere Senior was dead by then, and the younger Luneau found the right balance of parental affection and discipline in his mentor. "He would throw a saw across the room if I was two minutes late," he recalls. But it was what he needed.

Luneau was also diagnosed with ADD later in life, something the Sisters at St. Peter's never understood. "I had the highest scores in the class on tests, but I'd forget my homework," he says. His wife has a master's degree in special education, and with her help, he began to understand himself and his learning needs.

And he turned his back on addiction. "I quit everything," he said, "when I was fifty. It was February 22, 1999."

Luneau has since built homes and business buildings all across the country. He's stayed sober, and though he doesn't go to many AA meetings, "I know they're there if I need them." Most importantly, he's comfortable in his own skin.

"Be honest," he advises, "and then you'll know if you're comfortable."

And when a stranger mispronounces his name, he will cheerfully say, "It's O-*mare*."

As a public relations specialist with the U.S. Navy, Sandy Pinfield Miller lived all over the world in a thirty-seven-year career. Because she doesn't like Granite State winters, she's retired to Florida and even uses a cheeky flamingo as her signature. But when she talks of Concord, she uses the word *home*, and she tries to make it home at least once a year.

"I was happy here," she said. "I had a great childhood, I loved school and I loved my friends. If you don't know what you don't have, you don't miss it."

Though Karon Devoid also now lives in Florida, she says, "I consider my hometown Concord, and I always will." When she found she was pregnant with her daughter, she recalls, "I wanted to raise her here. That was my 'grounding.' I wanted her to have the same foundation I had."

Mike Philbrick had a career in law enforcement and ended up in California. But he attributes a lot of his character to Concord. "It was a good foundation to be a good human being," Philbrick says.

Jim Wentworth worked in finance for a good chunk of his life. He and his wife, Martha, bought a vacation home in North Troy, Vermont, and it ended

up being their permanent home. He ran a movie theater, "the best job I ever had," before retirement.

"Concord taught me right from wrong," he says. He also drew from his mother Edna's positive personality and "great sense of humor," he says, adding, "She had a song in her heart."

Frank Perron stayed in the sciences, though not blowing things up. He got his PhD at the University of Hawaii, became a marine biologist working in the Pacific Ocean and finished his career as a technical writer. He was to find his forever home in Bradenton, Florida, but he says he "loves going back" to Concord. He meets his siblings in New Hampshire about once a year, and they do something together. "It is often Concord," Perron says.

But it's not the Concord he knew. "It's almost unrecognizable," he says. "It's so much bigger, so much going on." Some stalwarts are still there, such as the Granite State Candy Shop, he adds.

Christine Prentiss Gifford studied occupational therapy at UNH and moved to New York State because there were more opportunities to work with senior adults, her clients of choice. She met her husband there and made her home there. But she credits Concord with shaping her character. "I think it shaped me for the better," Gifford muses. "It taught me good values. I learned to grow up, hold a job, be kind to people."

Allan Stearns now lives in northwest Florida. He had an air force career before being diagnosed with medical issues stemming from exposure to Agent Orange and retiring on disability. He enjoys his later-in-life call to the ministry. And music is still an avocation. He sings in his church choir and a barbershop quartet, interests fostered during his Concord childhood.

Paul Lillios still lives in Concord. He says, "When I travel, and I talk about home, people listen. They say, 'What a great place,' and I say, 'Yeah, it really was.'"

Brenda Woodfin Thomas now lives in Bedford and remembers Concord as "super easy to grow up in. We didn't see any problems in the world until we were older. We were immune to a lot."

Jim Rivers went on to have a career in broadcasting and politics. He remembers three things that shaped his character: his mother's courage as a young widow, the discipline at St. John's School and the lessons from being a Boy Scout.

Paul Brogan saw what was beyond the top of the Carpenter Hotel. He lived and worked in Hollywood, carried on a lifelong friendship with Doris Day and met other notables. He returned to Concord with a wealth of film knowledge, which he shares teaching in local colleges. He celebrates his

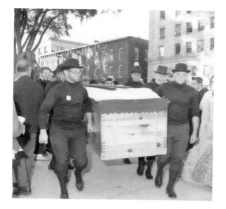

Left: Residents prepare for the burial of "Mr. Ray Zor" during the bicentennial in 1965. It was the formal kickoff of the Brothers of the Brush. *Alfred Perron.*

Below: Governor John King looks at the first-ever New Hampshire Lottery ticket in 1964. The lottery was enacted to help pay for public education, and it did for a while, until the world and the needs of students became more complex. *Alfred Perron.*

hometown with a weekly program on Concord Community Television, has published three books and is active in promoting other local authors.

Marc Boisvert lived in Manchester while attending nursing school and worked as a paramedic for five years in Albany, New York. He came back to Concord in 1993 when his father died, and he stayed on. "I know Concord," he says simply.

Boisvert knows Concord in another sense, as founder and moderator of the popular Facebook page Concord, New Hampshire Then and Now. He

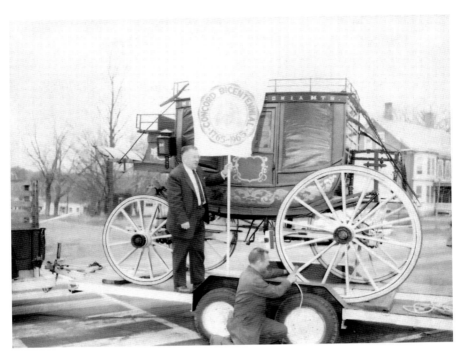

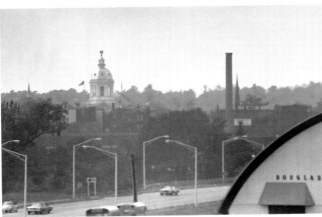

Above: The Concord coach is prepared for its trip to the New York World's Fair in 1965. Remember world's fairs? *Alfred Perron.*

Left: At the Bend in the River. *Alfred Perron.*

started it at a friend's encouragement. "He said, 'You're always in everybody's business anyway,'" Boisvert recalls.

The population of Concord was about twenty-five thousand in his youth and is now around forty-two thousand, "a big jump," according to Boisvert. And there are other changes. "I'm amazed," he says, "when people are rude. I'm amazed that we've had a few murders."

But he's pleased with current mayor Jim Bouley and excited about the revived downtown. "It's great seeing people communicating, getting together," Boisvert says.

And he'll blend Concord's new cool with the small-town goodness of his youth. When he moved back to Concord in 1993, he paid a visit to the Concord Theatre. "I knew they were closing soon—Theresa was almost blind," he recalls. But the intrepid theater owner remembered him.

"She told me, 'Marc, *you* don't pay.'"

GLOSSARY

Abbott, Betty: Iconic recreation director for the city who created programs such as the Peanut Carnival and the Ski and Skate Sale.

Audi, the: Chic new name for the remodeled City Auditorium, where most of us had our dance recitals, acted in Community Players offerings and watched the Walker Lectures.

Baby Bypass: Northern extension of Storrs Street connecting the Horseshoe Pond area with downtown.

Ballsy, Old: One of the cliffs from which adventurous boys jumped at the quarries.

Beetleplug: Our nickname for the Volkswagen and the basis for a car game where we had to hit each other four times whenever we saw a VW. Parents found it extremely nerve-racking, and when we could, they encouraged us to walk. A later generation reinvented the concept as Punch Buggy, which annoyed their parents just as much.

Britts: First major department store in town and the anchor store for the new Capitol Shopping Center.

Cantin, Theresa: Owner of the Concord Theatre, which she ran with her sister Rena Constant. She was a mother figure to generations of moviegoers, including the "girls" from the Friendly Club next door and Franky Transistor.

Capitol Theater: The "Cap," home of Saturday matinees, including cartoons and, in our earliest years, newsreels. An Art Deco treasure saved from the wrecking ball by a group of determined residents.

Carlen's Café: The premier dive of our childhood and the one parents warned us to stay away from.

Carnival, Peanut: A citywide recreation effort celebrating the end of summer with booths where kids could try games or buy snacks for, well, peanuts.

Channel Nine: The only commercial TV station in the state. We could "get" three Boston stations, but Channel Nine was ours.

Clubs:
American Legion: Post 21 was founded by Dr. Robert O. Blood in 1919. He was a beloved Concord physician and East Concord dairy farmer. He served in the U.S. Medical Corps Twenty-Sixth Division from 1917 to 1919, serving in both Britain and France. Post 21 sponsors a youth baseball team and has an Auxiliary and a Sons of the American Legion. Currently located at 7 Perley Street.
DAR: Daughters of the American Revolution. The Buntin-Rumford-Webster chapter serves Concord. The organization also fosters the Children and Sons of the American Revolution.
DAV: Disabled American Veterans. This group flourished in the fifties and early sixties, as members of the Greatest Generation came back without limbs or eyes. The war's fallout was all around us as we saw the damage in our friends' fathers or our fathers' friends. In true Greatest Generation form, they kept most of their interior wounds to themselves. Post 19 has a Facebook page.
Eagles Club: Fraternal Order of Eagles (FOE). The Eagles claim founding in February 1898 in Seattle, by a group of theater owners concerned about a musicians' strike. They came to an agreement and formed the Order of Good Things, which was later to adopt an eagle as its symbol. The FOE claims credit for the founding of Mother's Day. Aerie No. 613: 36 South Main Street, Concord.

Elks Club: Benevolent and Protective Order of Elks (BPOE) Chapter 1210 now meets in Epsom. Outreach includes scholarships, youth basketball and services to veterans.

Emblem Club: Female arm of the Elks.

Kiwanis Club: "A global organization of volunteers dedicated to changing the world one child and one community at a time." Key Clubs for high school students meet at CHS, MVHS and Pembroke Academy. Scholarships; sponsors of annual spring fair at Everett Arena.

Masons: International fraternal organization claiming some of our Founding Fathers. Our Founding Mothers joined the Order of the Eastern Star, and their kids kept busy with Rainbow Girls and Demolay.

Moose Club: Chapter 279. Now closed.

Passaconaway Club: Men's club formerly located on Garvins Falls Road.

Quota Club: National service organization for women with a focus on services for women, children and the deaf and hard of hearing. Dissolved in 2020.

Rotary Club: International service organization. Roteract Clubs for young adults, Interact Clubs for teens. Concord has two chapters, the Rotary Club of Concord and the Capital City Sunrise Rotary Club.

Veterans of Foreign Wars (VFW): Post 1631. Organization founded in 1899 by veterans of the Spanish-American War and Philippine Insurrection. Concord chapter still active at 6 Court Street.

Wonolancet Club: Men's club formerly located at North State and Pleasant Streets.

Zonta Club: "Empowering women through service and advocacy." Scholarships. According to the club's website, "Zonta" is derived from a Sioux Indian word meaning "honest and trustworthy" and was adopted in 1919. Concord chapter is still active.

Colter, Virginia: Elderly Quaker woman who ran the Peace Center on Pleasant Street during the Vietnam War. A safe place for young people to come and discuss the war, and a little more cerebral than Critter Corner.

Concord coach: The premier vehicle for opening the West; Concord's main import in the nineteenth century. They were made by the Abbott-Downing Company. We were trained to spot them in the early Westerns.

Concord Theatre: A small and intimate venue run by two French Canadian women. In a community effort, it was remodeled into the Bank of New Hampshire Stage and honors its past while hosting the best of modern music and entertainment.

Critter Corner: An area on Main and Pleasant Streets where disaffected youths hung out during the Vietnam protest era.

Fosterville: The "northest" part of the North End, near the cemetery.

French's: A pair of shops on Warren Street. The toy shop was a mecca for kids, the music shop a magnet for teens. We bought our first Beatles albums there.

Gus, Uncle: Beloved children's TV host on Channel Nine, showing Popeye cartoons on weeknights. We also liked *Major Mudd*, a show out of Boston, where a man played an astronaut in a cardboard spaceship and showed Three Stooges movies every weeknight.

Heights: A wild and desolate neighborhood on the other side of the river. Not thickly settled until well into the fifties, its other names were "the Plains" and "Burglar's Island."

Hill, the: The Auburn Street/Ridge Road neighborhood, occupied by doctors, lawyers and their offspring. Somebody had to be them.

Irving: One of the cliffs at the quarries.

Joy, Clyde: Country singer who appeared on Channel 9, with and without Uncle Gus.

Keniston's: Clam shack by the river. Popular with Catholic families on Friday nights.

McAuliffe, Christa: Beloved Concord High social studies teacher who died in the *Challenger* disaster on January 28, 1986. The McAuliffe-Shepard Discovery Center was built in her honor and renamed to also honor fellow astronaut Alan Shepard, the first American in space.

Peckerville: Nickname for East Concord. It's not as bad as it sounds; it honors a war hero who happened to have an unfortunate name.

Phenix Hall: Stately building on Main Street. Yes, that's how it's spelled. Abraham Lincoln spoke here on March 1, 1860.

Pierce, Franklin: The only U.S. president from New Hampshire, who also lived for a time in Concord. Somebody had to be him, too.

Quarry, the: A series of granite quarries on the west side of town, including the mammoth Swenson operation, still in business today. Teens, usually boys, jumped off the cliffs into the water below.

Quinn, J. Herbert: Mayor of Concord for a couple of years in the mid-sixties. Carried on an active war with Jim Langley, publisher of the *Monitor*, and most of his aldermen. He was impeached in August 1967. I don't get too much into him in this book because his antics didn't affect us as children, but he's worth a look if you're interested in Concord history.

Rumford Press: A principal employer in the twentieth century, printing national magazines and employing up to one thousand people.

Rumford, Count: Born Benjamin Thompson, he was an eighteenth-century physicist and inventor. He was a British loyalist during the Revolution, but we haven't held that against him. He returned to England and was knighted by George III in 1784 before moving to what is now Germany. His challenges to the established physical theory were part of a revolution in thermodynamics. He also drew designs for warships; conducted experiments with gunpowder during the war; invented "Rumford's Soup," a nourishing soup for the poor; designed parks for the emperor of Bavaria and established the cultivation of the potato in Bavaria. His connection to Concord is a little tenuous—he married Sarah Rolfe, a wealthy Concord resident, when the town was still called Rumford, and he styled his title after that town. He did not invent the baking powder credited to his name, but he did invent an early form of thermal underwear, so there's that.

Shepard, Alan: A native of nearby Derry and the first American in space. Practiced golf game on moon.

Speedway: The New Hampshire Motor Speedway in nearby Loudon, formerly Bryar Motorsports Park and home to national racing action. Also the genesis for Motorcycle Weekend in Laconia, an annual June bacchanal and a chance for accountants and insurance salesmen to dress like Hell's Angels and buy stuff. Not too many go to the motorcycle races

happening concurrently at NHMS, the original impetus for the weekend, but the accountants and insurance guys also don't destroy a lot of property, so there's that.

Steeplegate: The town's first indoor mall, on D'Amante Drive off Loudon Road. It served Concord and the surrounding area well until the general malaise regarding malls and is currently awaiting its next use.

Tom Collins Store: A neighborhood store on the Heights that served "the coldest beer" and never quite got the hang of asking for ID.

Transistor, Franky: A young developmentally disabled man who tended to wander downtown with a transistor radio fixed to his ear.

Vinnie's: The town's first pizza parlor in the triangle building at the confluence of West and South Main Streets.

Warren Street: A quaint Dickensian enclave, even quainter than Main Street, with the iconic Granite State Candy Store, the Apple Tree Bookshop, the Dorothy Bailey dress shop, French's Radio and, incongruously, the police station.

White's Park: *Always* "White's," never "White." The city's main recreation area, with a real pond that froze in winter, a skate house, piped-in music, kiddie playgrounds, basketball courts and more.

INDEX

M

N

O

P

Q

R

S

T

Trojan Horse 157
Tucker, Rick 104, 109, 136

V

Vietnam War 164
Vintinner, Lynn 23

W

Walker, Fred 24, 44, 63, 105, 108
Walker lectures 90
Walker School 36
Warren Street 60
Wentworth, Jim 19, 71, 85, 97,
 105, 109
West Concord 17, 25
West End 25
White's Park 21

ABOUT THE AUTHORS

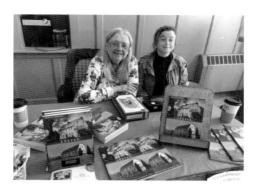

Kathleen D. Bailey (*left*) and Sheila R. Bailey.

Sheila R. Bailey is a freelance photographer living in Concord, New Hampshire. She enjoys traveling around her state and New England looking for the perfect shot. She recently coauthored *Exeter*, along with shooting the contemporary photos for *New Hampshire War Monuments: The Stories Behind the Stones*.

Kathleen D. Bailey is a journalist and novelist with forty years' experience in the nonfiction, newspaper and inspirational fields. While she's always dreamed of publishing fiction and has three novels in print, her two Arcadia Publishing projects, *Exeter* and *New Hampshire War Monuments*, made her fall in love with nonfiction and telling real people's stories. She lives in Raymond, New Hampshire.